IMAGES
of America

CYPRESS GARDENS

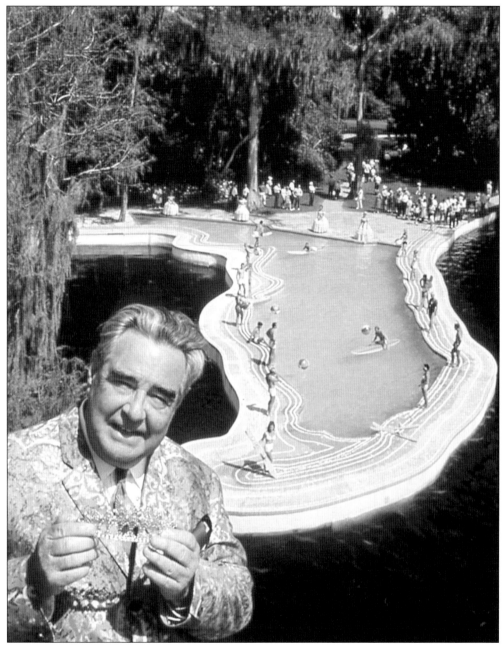

Dick Pope Sr. holds a sparkling pageant crown as he towers over the Florida-shaped Esther Williams Swimming Pool. Cypress Gardens was home to many pageants, including contests held on the pool deck. Pope was a born showman and enthusiastically promoted Florida, earning the moniker "Father of Florida Tourism." (Courtesy Cypress Gardens.)

ON THE COVER: Dick Pope directs a September 1957 photo shoot near the bridge to the historic botanical gardens. This spot was featured in period advertisements and postcards, as it represented the convergence of primary walking and boating paths and was familiar to all park visitors.

IMAGES
of America

CYPRESS GARDENS

Mary M. Flekke, Sarah E. MacDonald,
and Randall M. MacDonald

ARCADIA
PUBLISHING

Copyright © 2006 by Mary M. Flekke, Sarah E. MacDonald, and Randall M. MacDonald
ISBN 978-0-7385-4339-0

Published by Arcadia Publishing
Charleston SC, Chicago IL, Portsmouth NH, San Francisco CA

Printed in the United States of America

Library of Congress Catalog Card Number: 2006932175

For all general information contact Arcadia Publishing at:
Telephone 843-853-2070
Fax 843-853-0044
E-mail sales@arcadiapublishing.com
For customer service and orders:
Toll-Free 1-888-313-2665

Visit us on the Internet at www.arcadiapublishing.com

With thanks to our parents and to Burma Davis Posey
and the Friends of Cypress Gardens. You believed.

CONTENTS

Acknowledgments 6

Introduction 7

1. Building the Park 9

2. Promoting Cypress Gardens 23

3. The Gardens 39

4. Water-Ski Capital of the World 53

5. Boating at Cypress Gardens 73

6. Movies and Television 83

7. Celebrity Visitors 95

8. Park Expansion 105

9. Cypress Gardens Adventure Park 121

Sources Consulted 127

ACKNOWLEDGMENTS

Inspiration for this volume came from countless days spent at Cypress Gardens over the past quarter-century and from the many fine local history titles produced by Arcadia Publishing. Our thanks go to Adam Ferrell of Arcadia, who offered us reassuring encouragement and advice.

This work could not have been attempted without the generous assistance, enthusiasm, and hospitality of Kent Buescher, George Vitello, and Lynn Wright of Cypress Gardens Adventure Park. Together with Kevin C. Hehn of OneSource, they offered friendly encouragement and access to thousands of vintage Cypress Gardens images in scrapbooks and archival files. Most of these images are unique, and we appreciate greatly the opportunity to share them with a wide audience. Robert Fugate and Ken Griffin of Cypress Gardens Adventure Park and Jane Robertson of Adventure Parks Group also provided material assistance, for which we are grateful.

Dick Pope Jr. graciously shared his memories of Cypress Gardens—especially the water-ski shows—and for his magnanimity we are grateful.

To Neysa Nelms Mazzarese, we offer our appreciation for her kind response to our many questions.

For her assistance, wise counsel, and love of Cypress Gardens, we thank Susan P. MacDonald.

To our colleagues and friends at the Florida Southern College Library, we appreciate your affable spirit and professionalism. Andrew Pearson, Nora Gabraith, Eridan J. McConnell, Ann Rogers, Sally Gullage, and Lydia Lane: our thanks to you all.

INTRODUCTION

Richard Downing "Dick" Pope Sr. was a born showman and entrepreneur. With his brother Malcolm, Pope became well-known as a Florida-based speedboat racer and water-skier in the 1920s. Pope met his future wife, Julie Downing, in 1926 while golfing in Asheville, North Carolina, and later worked in public relations in Chicago and New York. After Julie Pope showed her husband a *Good Housekeeping* article about a man in Charleston, South Carolina, who had generated $36,000 in one year opening his garden estate to visitors, the Popes set about transforming a marshy tract of lakeside land in Winter Haven into a magnificent garden.

The Popes were a wonderful team; she had a green thumb, and he was a publicity machine. The Popes convinced the Federal Emergency Relief Administration to assist in developing the gardens, an effort that took several years. When the gardens opened on January 2, 1936, visitors paid 25¢ to tour pathways surrounded by lush plants from around the world. Electric boats were introduced two years later, taking visitors inland through hand-dug canals in the gardens.

Two of the park's most enduring traditions were launched by Julie Pope. When a 1940 freeze damaged the flame vine that marked the entrance, she positioned girls in antebellum hoop dresses to mask the vine, assuring visitors that the botanical gardens had escaped harm. Since then, Southern belles have greeted visitors throughout the park. The earliest water-ski shows also started quite by accident, after soldiers stationed in Orlando in 1943 saw a newspaper article about the park showing a water-skier and arrived asking when the ski show started. Julie Pope—ever innovative—invited the soldiers to enjoy the park, quickly assembled her children, Dick Jr. and Adrienne, and their friends, and an institution was born. Hundreds of soldiers showed up the following weekend, and the park developed into the "Water-Ski Capital of the World."

Dick Pope's tireless efforts to promote Cypress Gardens and the state earned him the titles "Father of Florida Tourism" and "Mr. Florida." Years before Disney World and other mega-parks, visitors arrived in Winter Haven to visit the Popes' lovely park. One key to his promotional success was distribution of thousands of photographs to newspapers nationwide, producing over 100 published photographs daily.

Movies brought scenes of Cypress Gardens to worldwide audiences. Portions of the 1941 Betty Grable and Don Ameche movie *Moon Over Miami* were filmed at the Gardens, as were the 1948 Esther Williams and Ricardo Montalban film *On an Island with You* and the 1953 romantic comedy *Easy to Love*, starring Williams, Van Johnson, and Tony Martin. The Florida-shaped "Esther Williams Swimming Pool" still graces the shore of Lake Eloise. Dozens of short features were filmed at the gardens, beauty pageants were staged against the lush tropical grounds, and television specials were broadcast from the park. May 2006 saw a return of the movies, with John Cusack visiting the park to film scenes for *Grace is Gone*.

The park expanded in the 1970s, adding a small zoo, rides, and the small-town Southern Crossroads shopping and dining area. The early 1980s saw the addition of the towering Island in the Sky, a rotating platform affording distant views of the Florida landscape. The Pope family sold Cypress Gardens in 1985 to publishing conglomerate Harcourt Brace Jovanovich; in 1989,

the park was sold to Anheuser-Busch. A group of former park managers purchased the park in 1995, but especially after 2001, they were faced with declining attendance and revenues. To the dismay of the entire community of Cypress Gardens aficionados, the park closed in April 2003.

After a series of negotiations between the State of Florida and prospective buyers, and a grassroots publicity campaign led by Burma Davis Posey and others, Kent Buescher purchased Cypress Gardens in April 2004. Buescher worked tirelessly to restore Cypress Gardens to its former glory—and then some—with a grand reopening in December 2004. With more rides, a sparkling water park, an extensive concert and event schedule, daily water-ski shows, and restored botanical gardens, Cypress Gardens Adventure Park preserves the family-friendly appeal of Dick and Julie Pope's magnificent park.

Drawn from the archives of Cypress Gardens, the authors' personal collections, and area library collections, these images trace the development and life of Florida's iconic roadside attraction and celebrate those who make the park memorable.

One

BUILDING THE PARK

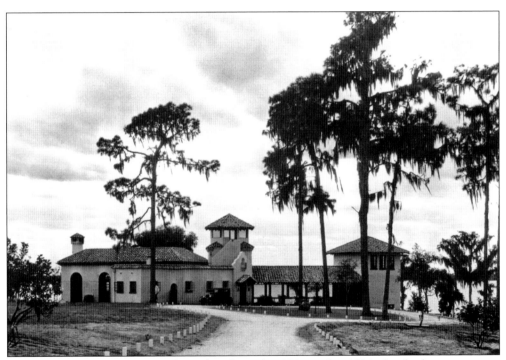

The 100 Lakes Yacht Club was formed in the early 1920s, and in 1924, they built a picturesque clubhouse on the eastern shore of 1,160-acre Lake Eloise. The club sponsored motorboat races beginning in 1925, with racers in heavy cypress boats powered by inboard motors. The Florida land bust caused closure of the clubhouse in 1926, and it sat dormant until Dick Pope Sr. leased it from John Snively as Cypress Gardens was developed. At that time, the building was redecorated using cypress paneling, and it contained a tearoom and souvenir shop. (Courtesy Cypress Gardens.)

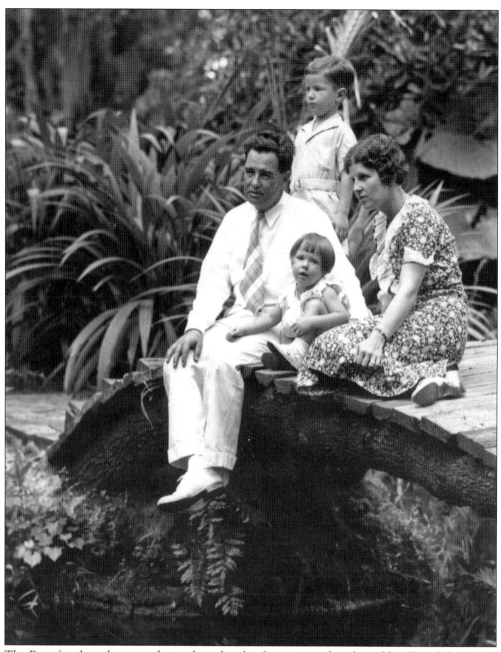

The Pope family is shown in the gardens shortly after it opened to the public. From left to right are Dick Sr., Adrienne, Dick Jr., and Julie. The original rustic bridges throughout the gardens were formed from large oak trees and were high enough to allow for passage of small watercraft. (Courtesy Cypress Gardens.)

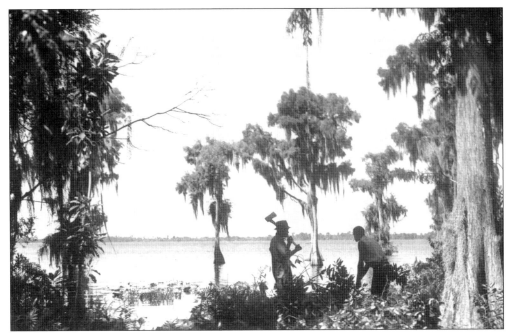

The Cypress Gardens archives identifies this 1932 photograph as the first image taken in the original nine-acre tract that would become the gardens. It depicts two men beginning the laborious process of clearing underbrush and preparing the land to accommodate canals, walking paths, and plant beds. (Courtesy Cypress Gardens.)

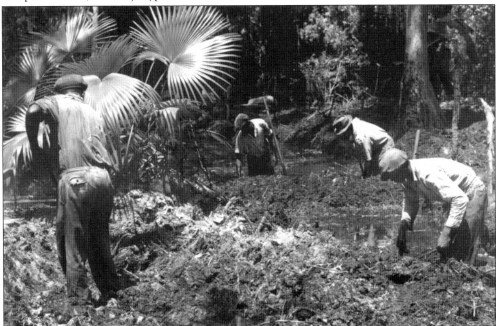

With cooperation from the local Federal Emergency Relief Administration (FERA) office, Pope hired men at $1 a day to create the gardens. This image shows the early stages of digging canals through the lakeside tract. The canals served a dual purpose, assisting with drainage and beautifying the landscape. (Courtesy Cypress Gardens.)

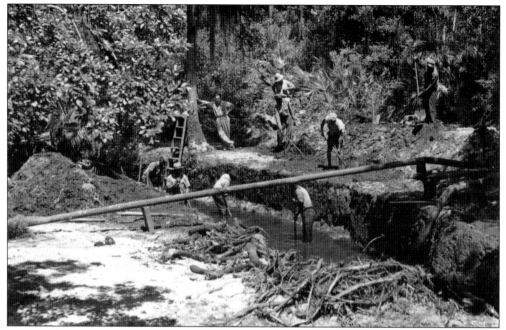

Digging the canals was a labor-intensive process and required periodic pumping to permit further construction. Placement of every element of the gardens was quite purposeful. Pope used a camera viewfinder to plan the landscape design, including the position of the canals. (Courtesy Cypress Gardens.)

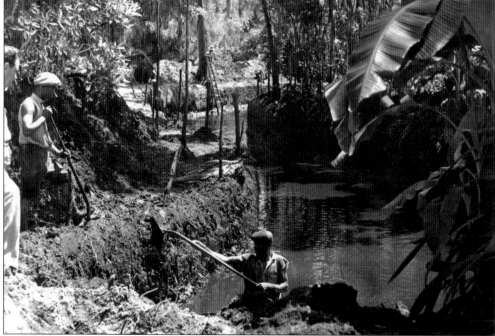

Markers were used to project the path of the canals. In some areas, the canals open into wide reflection pools. After the channels were created, wooden walls were installed to line the canals, to provide both stability and a finished look. (Courtesy Cypress Gardens.)

A pair of workmen digs the canal bottom, loading the muck onto a small construction boat. Local opposition to the use of government funds grew as construction continued, and FERA cancelled the project. Pope secured enough funding to have the property deeded to the Florida Cypress Gardens Association, and work continued. (Courtesy Cypress Gardens.)

Workmen gaze toward the lakeside as a small craft passes the construction area. Within several years, hundreds of thousands of visitors would pass through the canals and the lovely gardens. (Courtesy Cypress Gardens.)

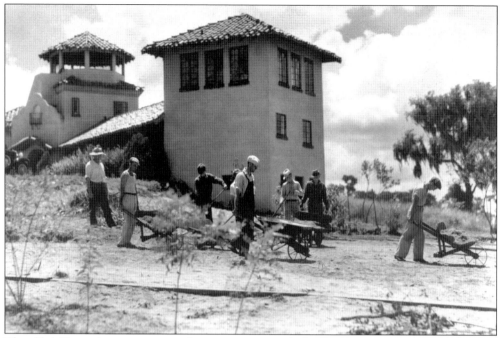

The old clubhouse became a center of activity as men used wheelbarrows to move dirt, wood pavers, and other materials into the new gardens. The clubhouse served as a recognizable park landmark until 1972, when it was razed to make way for a larger entrance. (Courtesy Cypress Gardens.)

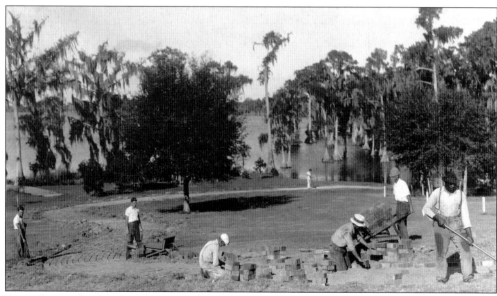

A winding path of pecky cypress pavers was built from the clubhouse toward the gardens during summer of 1935. A sawmill had been installed on the property, and for nearly a month, carloads of wooden blocks were prepared to be laid like bricks. (Courtesy Cypress Gardens.)

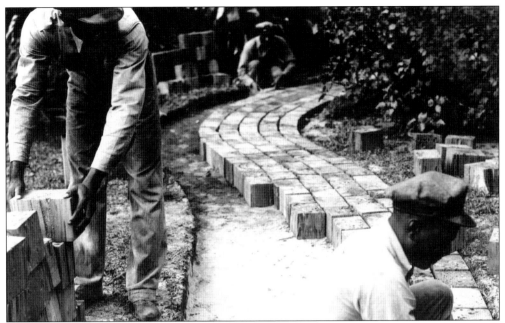

Walkway pavers varied in height, and the paths varied in width from four to eight feet. Over a mile of paths were created, leading to lush gardens where thousands of plants could be observed. (Courtesy Cypress Gardens.)

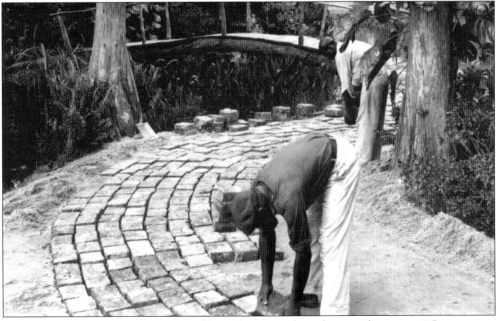

A December 1935 *Winter Haven Herald* article reported on the transformation: "Grass is now coming up between the blocks and through the holes in the pecky cypress and altogether the effect created adds to the charm and natural beauty of the show place of Central Florida. These blocks of pecky will last for hundreds of years, it is expected, as they are laid through the damp jungleland of the gardens and because of the nature of the wood will never decay or rot." (Courtesy Cypress Gardens.)

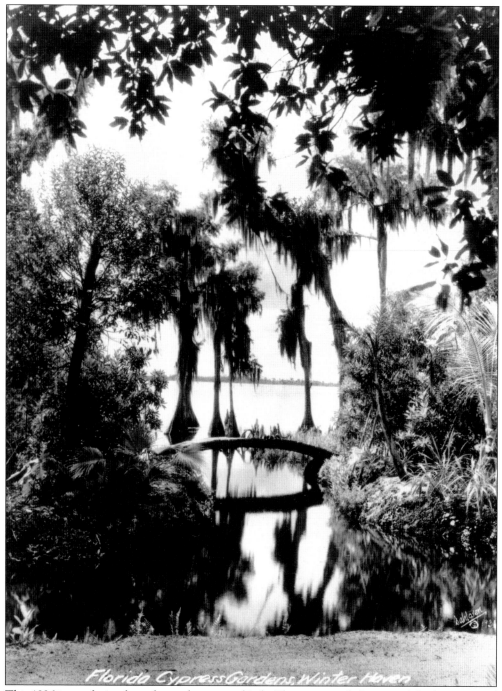

Florida Cypress Gardens Winter Haven

This 1936 image facing from the gardens toward Lake Eloise is regarded as one of the first postcard views of Cypress Gardens. The image was taken by Dahlgren Studios of Winter Haven, a primary early source of Cypress Gardens publicity photographs. (Courtesy Cypress Gardens.)

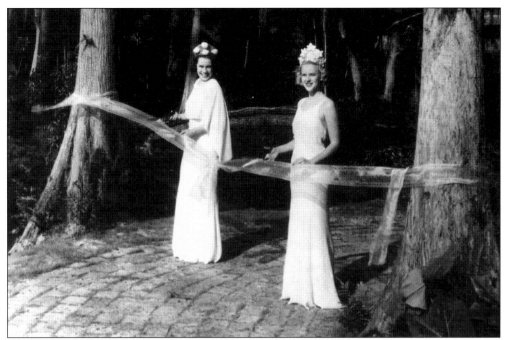

Local residents were invited to several open house events as construction progressed. The gardens were dedicated by Florida governor David Sholtz on January 24, 1935, during the Orange Festival; a preliminary opening was held on March 1, 1935; but the formal opening occurred on January 2, 1936. Cotton States Queen Elizabeth Hull (left) and Florida Orange Festival Queen Betty Runkle (right) were selected by Dick Pope to cut the satin ribbon as part of the ceremonies. (Courtesy Cypress Gardens.)

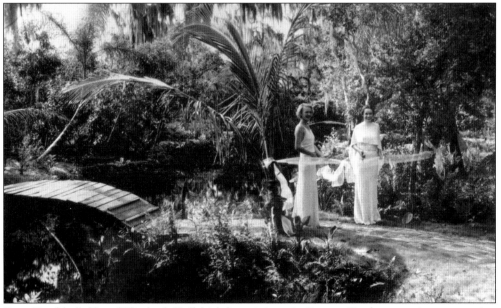

Betty Runkle (left) and Elizabeth Hull (right) participate in Cypress Gardens opening ceremonies. Hull sang "If You Wear a Little White Gardenia." After a brief rain shower, 182 visitors—who had paid 25¢ each—toured the grounds. (Courtesy Cypress Gardens.)

17

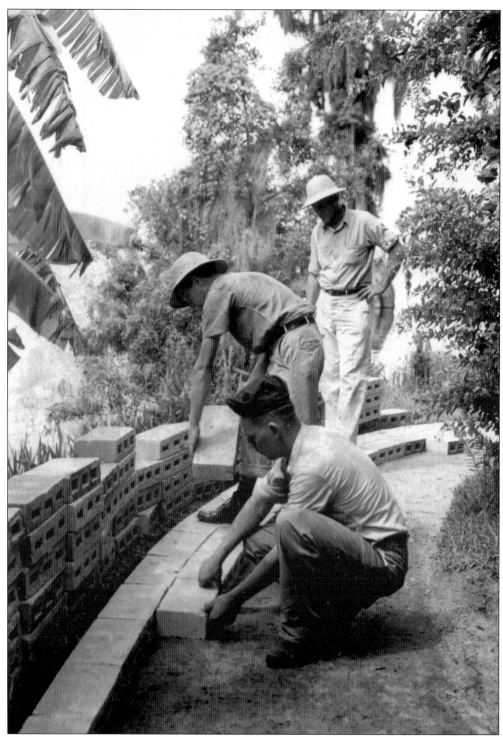

The early cypress pavers were eventually replaced with concrete block pavers, many of which are still in place in the historic botanical gardens. This image was recorded in April 1948. (Courtesy Cypress Gardens.)

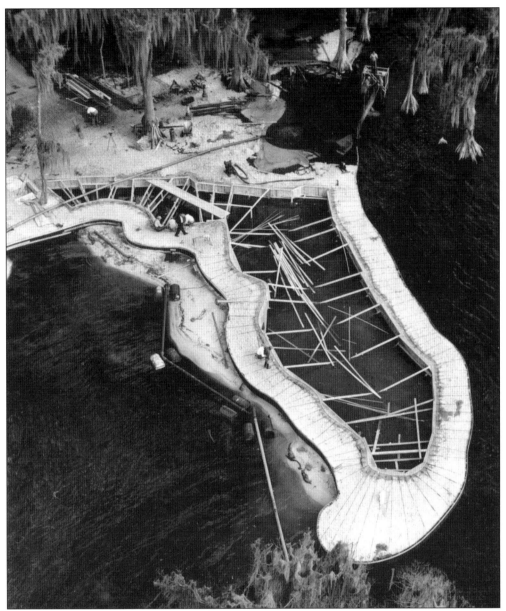

The 100-foot Florida-shaped Esther Williams Pool was constructed for her 1953 MGM romantic comedy *Easy to Love*, costarring Van Johnson and Tony Martin. The pool remains one of the park's most storied and unusual fixtures. Much of the film was shot locally, including exterior views of the Haven Hotel. The film culminated with a lengthy sequence featuring many of the park's talented water-skiers. (Courtesy Cypress Gardens.)

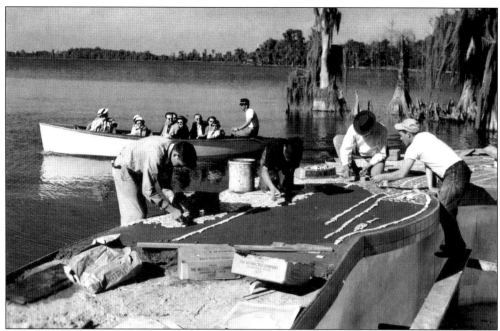

The elaborate tile work surrounding the Florida pool extended the edge of the pool deck to the seawall. Tiles at the southern end of the Florida map spelled "Happy swimming, Esther Williams." The tile work was eventually removed, and a narrow concrete walkway now surrounds the pool edge. (Courtesy Cypress Gardens.)

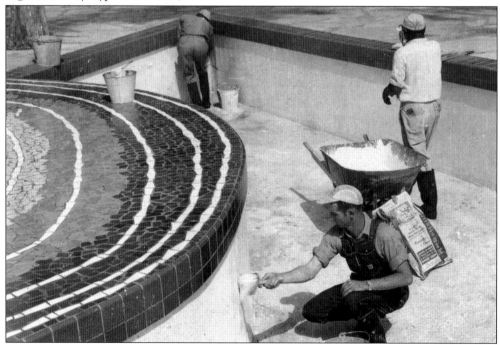

This image shows the pool nearing completion, with a final coat of sealant being applied. Promotional photographs and movie posters for *Easy to Love* made full use of this new landmark. (Courtesy Cypress Gardens.)

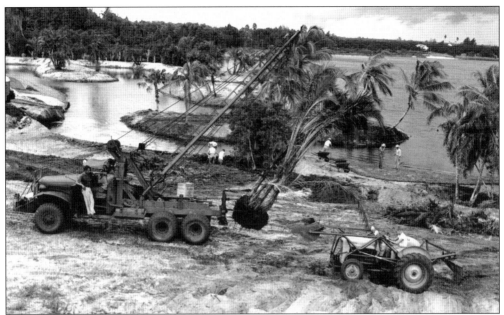

The 10 Tropical Isles of Movieland were constructed in 1956 at the north end of the park. The islands were created from dredged lake bottom by Paul Summerall using an enormous steam shovel to create several peninsulas. Large palms were planted, then each peninsula was cut into separate islands, and extensive landscaping followed. Each island is unique, and they have been used as backdrops for advertising photography, television broadcasts, and movies. (Courtesy Cypress Gardens.)

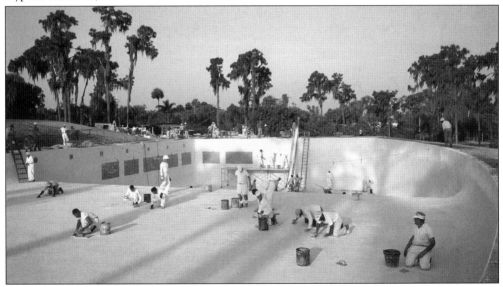

The spectacular Aquarama pool was constructed for the 1960 television special *Esther Williams at Cypress Gardens*. The pool featured a series of underwater windows, through which photographers with still and motion picture cameras could view swimmers from an underground chamber. Annual Amateur Athletic Union–sanctioned swim meets were later held in the 283,000-gallon, 55-yard pool, including one of the state's first computerized meets in 1969, "with results printed within minutes after the competition has been completed." (Courtesy Cypress Gardens.)

The Cypress Gardens clubhouse was demolished in November 1972 as part of a $6-million expansion program. The clubhouse had seen service as a gift shop, administrative offices, the water-skiers' dressing room, and as the main park entrance for nearly 30 million visitors. A new entrance building was subsequently constructed on the same site. The building program included construction of a 1,500-seat lakeside stadium, bringing to 2,400 the number of covered seats. (Courtesy Cypress Gardens.)

Wings of Wonder, a 5,500-square-foot Victorian-style glass butterfly conservatory, was completed in 1993. Visitors come face to face with hundreds of stunning butterflies, a waterfall and stream, and beautiful flowering plants, all maintained at 80 degrees Fahrenheit, with 70 percent humidity. Caretakers hatch between 350 and 500 new butterflies each week—more than 50 diverse species— many from South American butterfly farms. Unhatched butterflies are visible in one of two glass-walled chrysalis houses; at any moment, a butterfly might emerge and join the group of 1,000 free-flying butterflies. (Courtesy Cypress Gardens.)

Two

PROMOTING CYPRESS GARDENS

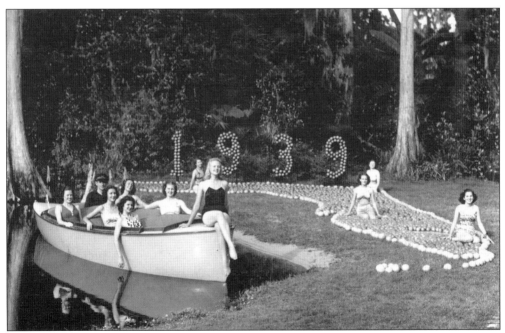

Key to increasing public awareness of Cypress Gardens beyond Winter Haven was the distribution of publicity photographs, such as this 1939 image. Photographs of the gardens, boating, young models, and local personalities were widely distributed to newspapers. Simultaneously the Popes worked to improve the gardens and watched with great satisfaction as the grounds matured. (Courtesy Cypress Gardens.)

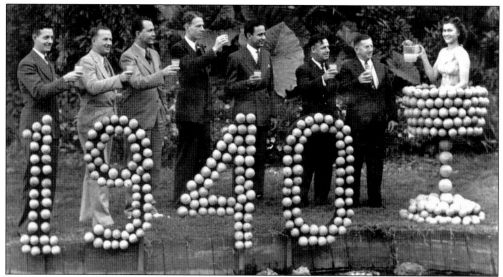

Perched in a large goblet, a young woman hosts visitors to the park in style. The year was 1940, and the park continued to draw attention. Early coups were performances by acclaimed ballerina Gail Armour, who had performed at the gardens shortly after it opened. During visits in 1936 and 1937, she and her company performed *Swan Lake* and *A Little White Gardenia*. A contemporary postcard image of Armour leaning against a cypress tree bore the title "Study in Knees at Cypress Gardens;" decades later, this image is still circulated and plays a role in the current perception of the park. (Courtesy Cypress Gardens.)

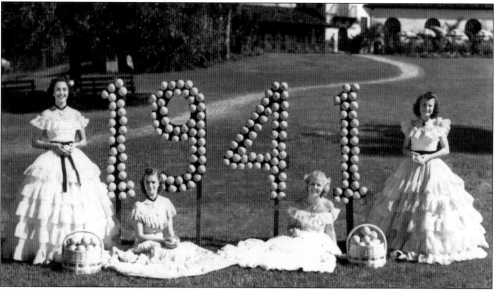

The Southern belles make an early appearance in this photograph from 1941. The attire was referred to as "old fashioned" in records from that time. In 1986, seamstress Betty Wheeler was constructing the gowns much as they had been for over 40 years. The gowns started as bolts of fabric draped across forms, pinned, pinched, and pleated as they took shape. Between 6 and 10 yards of fabric and 20 yards of lace and trim was used for each dress. Approximately 75 gowns were on hand, allowing for various colors and fabrics to be seen simultaneously. (Courtesy Cypress Gardens.)

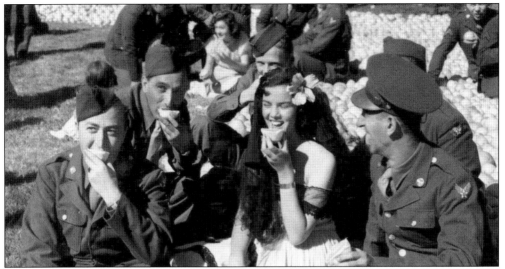

Citrus arranged in the shape of the state of Florida provided a backdrop for military troops visiting the gardens during World War II. Dick Pope served stateside in the Army Signal Corps during the war, during which time responsibility for running Cypress Gardens fell squarely upon Julie Pope. The park faced daily challenges, chief among them flagging attendance, as rationing and other hardships of war affected all aspects of American life. Her response included a media blitz, keeping the gardens in the news, and initiation of the water-ski shows, which insured the viability of the park. (Courtesy Cypress Gardens.)

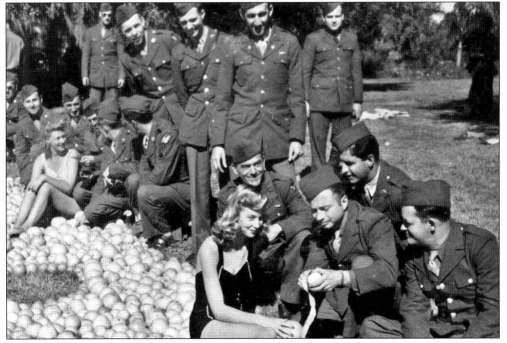

Hundreds of troops visited during wartime, in convoys numbering 1,500, both to witness early ski shows and as a welcome diversion from training. Cypress Gardens was one of the few attractions that remained open during the war, and the park used its gas ration—15 gallons per week—to provide ski lessons to troops. (Courtesy Cypress Gardens.)

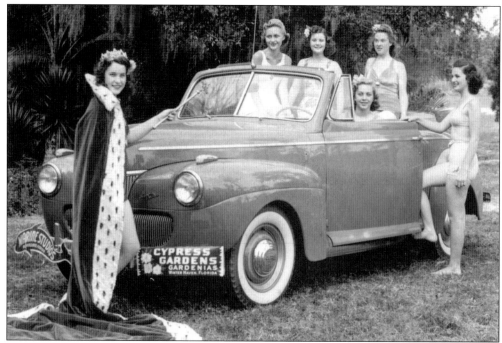

Identified only as the "Gardenia Queen and her court," these early beauty pageant contestants pose with a 1941 Ford Super Deluxe convertible as a prop. Park employees later recalled that Dick Pope would ask new car owners to bring their vehicles to the gardens for photo shoots, ostensibly to be submitted as advertisement photographs. (Courtesy Cypress Gardens.)

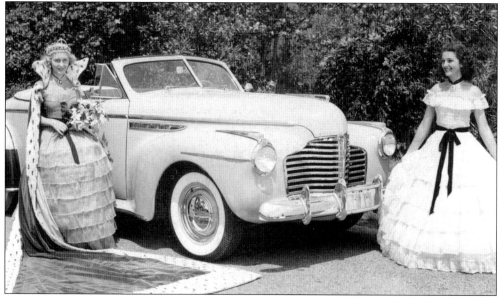

Kathleen "Katy" Turner (right) poses with an unidentified beauty pageant queen beside a 1941 Buick Roadmaster convertible. Among other pageant winners crowned at the gardens was 17-year-old Neva Jane Langley of nearby Lakeland, who in December 1949 was named Florida State Tangerine Queen. The popular Langley was crowned Miss America in 1953 while attending Wesleyan College in Macon, Georgia. (Courtesy Cypress Gardens.)

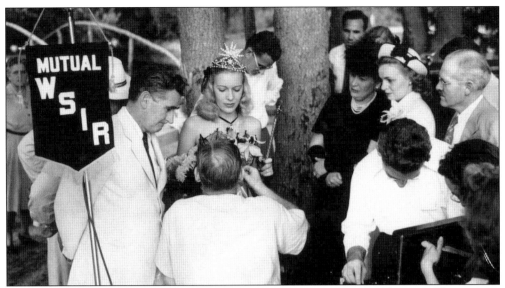

The crowning of beauty pageant contestants began in earnest after World War II. The contests generated substantial local publicity for the park. As many as 100 queens were crowned annually for practically every flower that existed and to celebrate many other events and products. A sampling of queens included: Miss Azalea, Miss Camellia, the Cigarette Queen, the Elder Blossom Queen, the Florida Tangerine Queen, Miss Gardenia, Miss Imperial Polk County, Miss Orange, Miss Orchid, Miss Rose, Miss Smile, Miss Watermelon, and Miss Zinnia. WSIR was founded in 1947 as the county's second oldest radio station. "Sir Radio" became known for many local remote broadcasts; this beauty pageant coronation made for compelling radio. (Courtesy Cypress Gardens.)

The Queen of Cypress Gardens is crowned by Edgar Bergen (right center) and his dummy, Charlie McCarthy. Bergen, the popular radio and television ventriloquist, visited the park in January and February 1952. (Courtesy Cypress Gardens.)

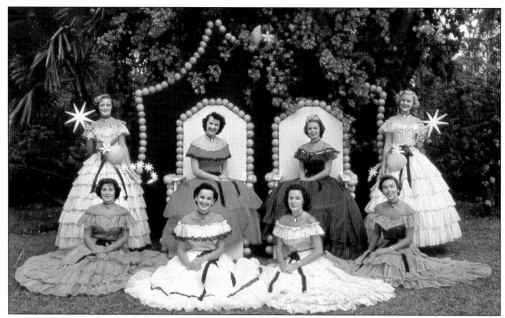

The California (left center) and Florida (right center) Citrus Queens smile for the camera in this undated view from Cypress Gardens. This image is likely from the early 1950s. (Courtesy Cypress Gardens.)

A citrus queen throne stood near the lake side of the clubhouse for many years; after the clubhouse was demolished, a succession of similar thrones was at the west end of the new entrance. This was a popular site for taking personal photographs, where anyone could pose as king or queen for the day. This photograph dates from the 1940s. (Courtesy Cypress Gardens.)

Adrienne Pope (left) and Katy Turner (right) pose as Southern belles in front of the clubhouse. Turner was a state champion water-skier and jumper and served as secretary of the Cypress Gardens Association. During a December 1945 tricks demonstration, she performed "jitterboarding"— standing on a single board pulled by a motorboat, without a tow rope. Buddy Boyle, Marion Clapp, Bob Harmon, Helen Hatfield, Marion Holmes, Frank Pierce Jr., Dickie Rowe, Nance Stilley, and Jack Yarbrough also participated in the day's events. (Courtesy Cypress Gardens.)

Toni Valk (left) and Bonnie Weise (right) offer friendly assistance to a photographer in April 1959. Valk was an accomplished water-skier who had a role in 1952's $2-million *This is Cinerama*, the groundbreaking film highlighting Cypress Gardens skiers and boaters. Kathy Darlyn and Trammell Pickett also starred in the 23-minute portion of the film devoted to the park. (Courtesy Cypress Gardens.)

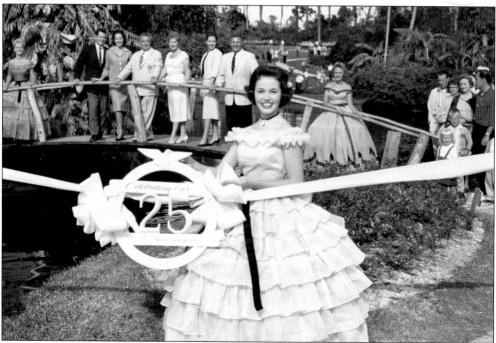

The Pope family and a crowd of well-wishers marked the 25th anniversary of Cypress Gardens in 1961. The park became phenomenally popular during the 1950s, thanks in large measure to the exposure gained through Hollywood films. (Courtesy Cypress Gardens.)

It's a birthday trip to Cypress Gardens, and what would any youngster enjoy more than posing with the Southern belles? Tommy and Susan Priest of Dade City, Florida, explored the park for the first time during this September 1967 visit. (Courtesy Betty Jo Priest.)

This is the quintessential view familiar to Cypress Gardens visitors, overlooking the "big lagoon" toward the picturesque wedding gazebo. Southern belles are among the most photographed young women in the world. In 1986, it was estimated that belles were photographed more than 500 times a day, and according to Kodak, more film was purchased at Cypress Gardens than at any other Florida attraction. (Courtesy Cypress Gardens.)

In a rite of passage for many young women in Winter Haven, those who work as Southern belles represent Cypress Gardens in a unique manner. Pam (left) and Karen Moore (right) are shown here as belles in 1996 in a photograph taken by local Gloria Moore Photography Studio. Susan and Joy Smith were another pair of sisters who worked as belles. The tradition of having young women dress in antebellum attire to greet visitors was initiated by Julie Pope in 1940. After a hard freeze damaged the flame vine that marked the park entrance, she positioned young women in antebellum hoop dresses to mask the vine, assuring visitors that the botanical gardens were still beautiful. Southern belles have greeted visitors for more than six decades and are an immediately recognizable symbol of Cypress Gardens. (Courtesy Cypress Gardens.)

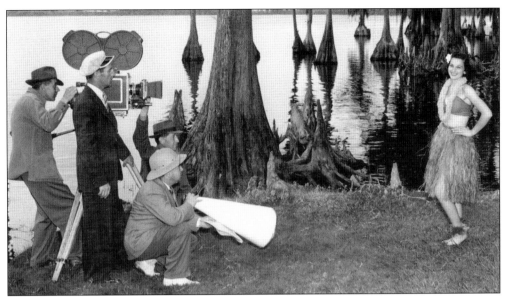

Dick Pope directs a filming session in the gardens. Pope appeared in many promotional photographs directing other photographers, helping to promote photography as an expected activity for visitors. This undated photograph likely dates from the early 1940s. (Courtesy Cypress Gardens.)

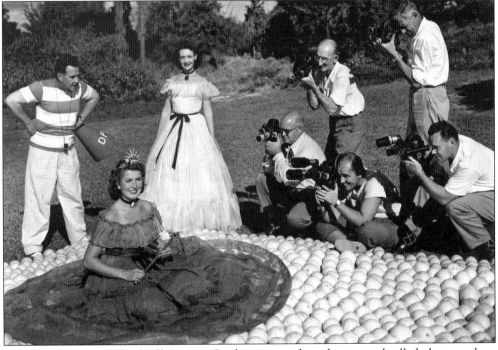

Images such as this helped sell Cypress Gardens to a wide audience: enthralled photographers focus on a belle surrounded by grapefruit, with a second belle brought in for good measure. Surely there was something enticing about Central Florida to winter-bound Northerners! Most of the young women who modeled for Cypress Gardens lived in Winter Haven and surrounding communities. A smaller number of professional models were photographed at the park. (Courtesy Cypress Gardens.)

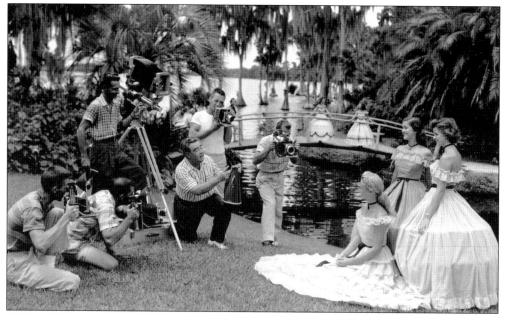

The bridge to the botanical gardens forms a backdrop for this September 1957 photo shoot directed by Dick Pope. This spot was featured in period advertisements and postcards, as it represented the convergence of primary walking and boating paths and was visible to park visitors as they passed through the main entrance. (Courtesy Cypress Gardens.)

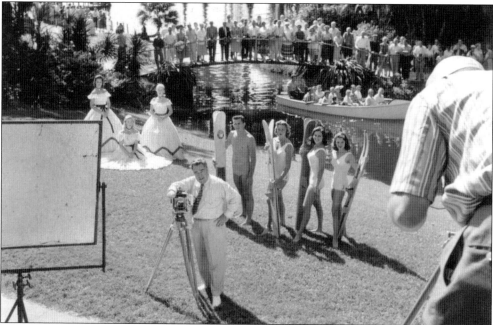

This April 1958 photograph neatly sums up Cypress Gardens. Photography played an important part in publicizing the park, the popular water-ski shows, the lovely Southern belles, the bridge to the botanical gardens, and the electric boats gliding silently beneath park visitors. Images such as this were carefully choreographed to promote the popularity of the gardens and diversity of attractions. (Courtesy Cypress Gardens.)

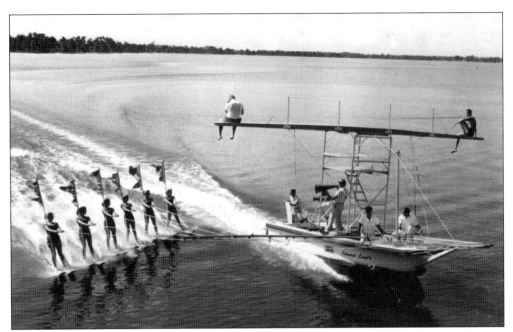

Ingenious methods were devised to capture photographs and moving pictures of Cypress Gardens water-skiers. This was one of several picture boats used to gain a unique and safe vantage point for photography. Closer to shore, a succession of photograph piers was constructed to provide professional and amateur photographers close proximity to passing skiers. (Courtesy Cypress Gardens.)

Skiers passed especially near the photograph pier at the north end of the water-ski show arena when entering or leaving the area, and photographers received cues to assist in their efforts. This wooden pier was photographed in November 1960. Eventually it was replaced by a metal pier in the same location. (Courtesy Cypress Gardens.)

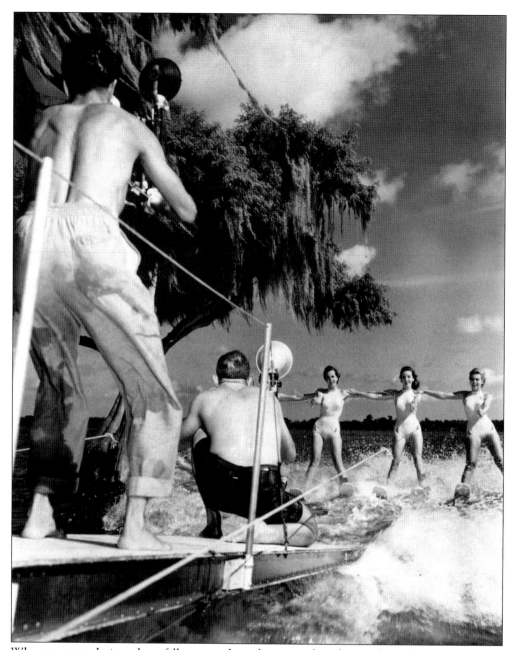

Who was more daring: these fellows speeding along untethered on a photo boat, or the lovely young skiers trailing close behind? Between dodging cypress trees and the hazard of falling cameramen, these skiers look remarkably composed. These four skiers, one of whom is partially obscured, were being photographed by these men for Dick Pope Sr.'s 1958 book *Water Skiing*. (Courtesy Cypress Gardens.)

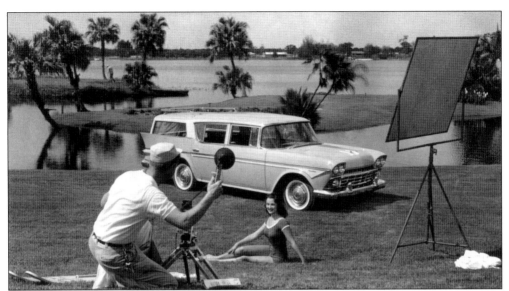

The Tropical Isles of Movieland offered a stunning backdrop for Dennis Hallinan as he photographed water-skier Joan Faye for Rambler Custom Cross Country station wagon advertisements during March 1958. Hallinan was a photographer at the gardens for 11 years. (Courtesy Cypress Gardens.)

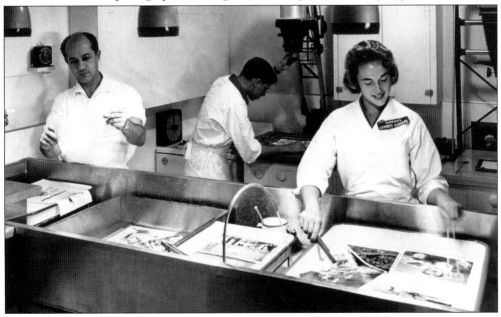

From its inception, publicity was central to the success of Cypress Gardens, and photographs paved the way for public recognition. Pope believed in using "our picture material plus other people's money"—OPM2—to fuel his media blitz. Thousands of photographs of the park, often including lovely young skiers, were distributed en masse to media outlets nationwide. The pictures were appealing and sold the name and concept of Cypress Gardens to a receptive public. A new photo lab was constructed in 1956 to support this publicity machine. The lab received a real workout during the 1957 World Water Ski Championships, when crews under the direction of Frank Maggio worked two shifts to print the 400–500 prints distributed to newspapers every day. (Courtesy Cypress Gardens.)

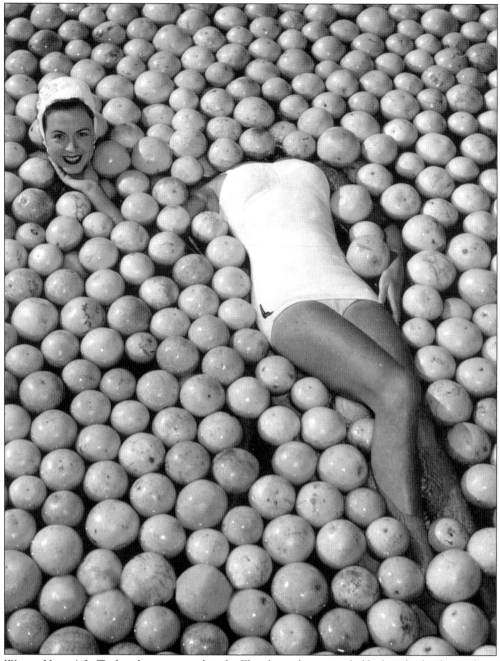

Winter Haven's Jo Tapley clowns around in the Florida pool, surrounded by hundreds of grapefruit. Advertising with citrus was productive for Cypress Gardens and for the citrus industry, which had a substantial economic impact in Polk County. (Courtesy Cypress Gardens.)

Three

THE GARDENS

This early publicity photograph shows guests and gardeners carefully posing in the newly created botanical garden *c.* 1935. Jim Doles Sr. worked for the park as caretaker beginning in 1936, helping to shape the early gardens. In March 1942, he and his family became the first African American visitors to the park. With his wife, Annie M. Doles, Jim Doles made history with children Betty, Jacqueline, James Jr., Richard, and Walter. The Doles family enjoyed a connection with Cypress Gardens for many years, as Richard and Walter were park employees and Jacqueline worked at the adjacent hotel. (Courtesy Cypress Gardens.)

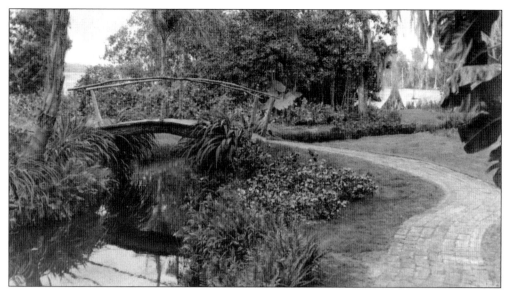

The earliest professional photographs of the park were by Robert (Bob) and Helen Dahlgren of Winter Haven. Dahlgren Studio advertised hand-colored views, commercial photography, picture framing, and portrait photography as early as 1928. This hand-colored Dahlgren photograph records a classic view looking into the gardens. Pope credited Bob Dahlgren with teaching him about photography in a 1959 *Winter Haven Herald* article; by then, Pope was no longer actively taking photographs but had hired a large staff of specialists. (Authors' collection.)

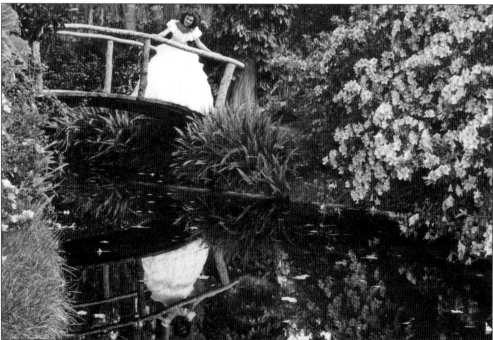

A crystal-clear reflection offers two views of Martha Mitchell in this December 1947 image. The promotional photograph was distributed through Acme Newspictures and proclaimed a white Christmas in Florida against a "canal banked with thousands of white azalea blossoms." (Authors' collection.)

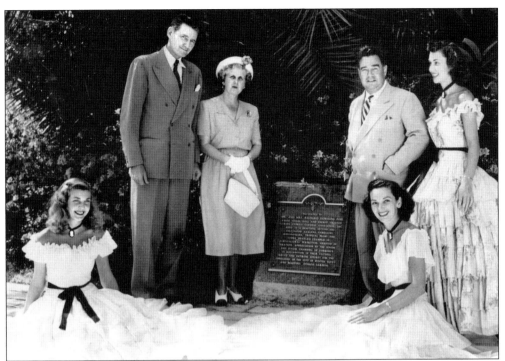

Florida governor Millard Caldwell (second from left) joins Julie and Dick Pope in February 1948 to unveil a plaque dedicated to the Popes "in recognition of their faithful service and untiring efforts for the upbuilding of the City of Winter Haven and beautiful Cypress Gardens." The plaque was presented by the local Senior and Junior Chambers of Commerce. Joining in the event were, from left to right, Virginia Burkhalter, Katy Turner, and Martha Mitchell. (Courtesy Cypress Gardens.)

Garden pathways and belles are visible in this 1950s view of the canal north of the big lagoon. The popular wishing tree is visible at the left side between the path and the canal. Legend had it that anyone who made a wish while sitting on the trunk with closed eyes would have that wish come true within a year. (Courtesy Cypress Gardens.)

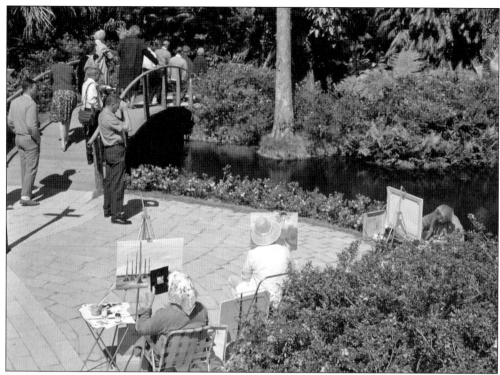

Painters capture scenes in the botanical garden in this undated image likely from the early 1960s. The artists were guests of the park for a special Art Week observance. (Courtesy Cypress Gardens.)

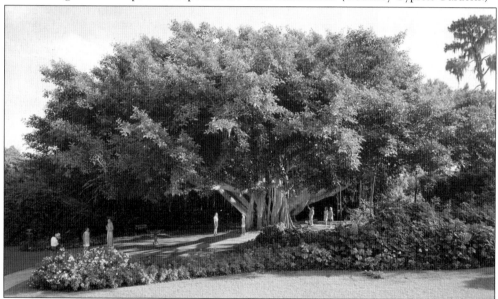

This enormous banyan tree (*ficus benghalensis*) was planted in 1936 by Dick Pope Sr. and is said to have arrived at the gardens in a five-gallon bucket. Seen here in 1971, the tree has grown rapidly to envelop the walkways with its massive aerial roots. The tree sustained minor damage during the 2004 hurricane season, when sections of the top were blown down. Statues of St. Fiacre and St. Francis of Assisi watch over the adjacent gardens. (Courtesy Cypress Gardens.)

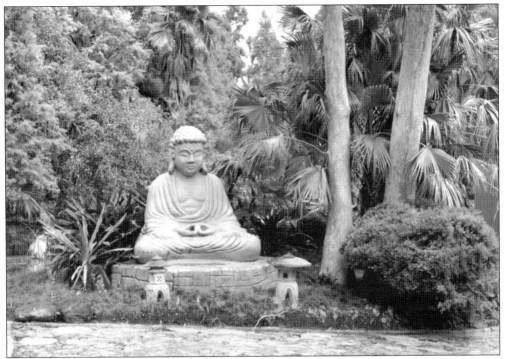

The centerpiece of the Oriental Gardens is the 12-foot gold statue of the Buddha of Kamakura. A dry river bed, Japanese teahouse, authentic oriental lanterns, and unique plantings complement this portion of the gardens, constructed in 1972. (Courtesy Cypress Gardens.)

Fantasy Valley was constructed south of the banyan tree in 1966 as a garden spot designed to appeal to children. It included animal sculptures, colorful bridges over small waterways, a tiki hut, and other interactive features. That year, the Cypress Gardens Citrus Festival float highlighted Fantasy Valley. (Courtesy Cypress Gardens.)

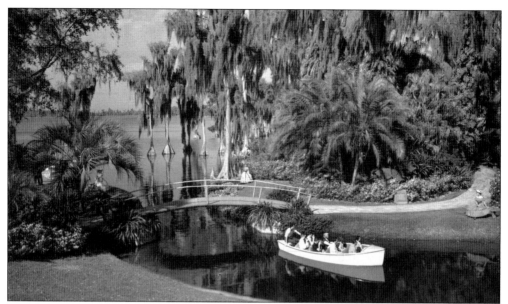

An electric boat enters the big lagoon under the first garden bridge in this 1950s view. It is interesting to recall that for much of the first decade, this is what Cypress Gardens was like; the gardens alone were the focus. The park offered a peaceful, fragrant, colorful respite from an increasingly complicated world. A large sign greeted visitors to the gardens with this poem: "If you'd have a mind at peace / A heart that cannot harden / Go find a door that opens wide / Upon a lovely garden." (Courtesy Cypress Gardens.)

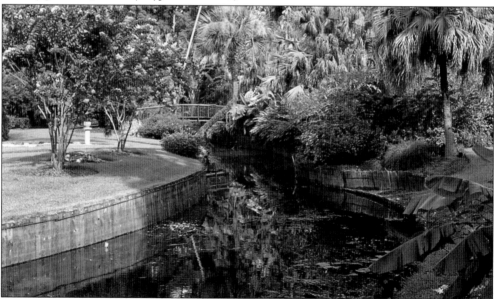

Seventy years after construction, the hand-dug canals are virtually unchanged. As envisioned and developed by the Popes, there are photogenic vistas at every turn. Surrounding the canals are some 80,000 plants, including 4,000 species of flowers from 75 countries. Many of the exotic plants were hand-selected by Dick and Julie Pope during trips abroad. Julie Pope was one of the first 10 national flower show judges in Florida; Dick Pope kidded in 1959 that he "didn't know an azalea from a petunia when we started." (Authors' collection.)

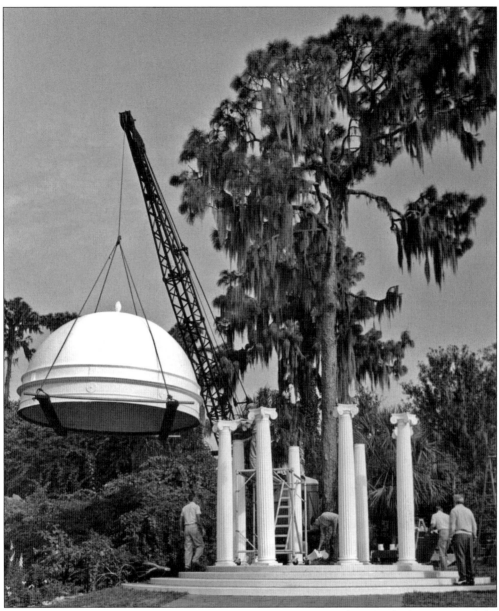

The wedding gazebo, known also as the Love Chapel, is situated on the highest point of the botanical gardens. The gazebo is the most photographed landmark in the park; one of the earliest is this construction image, taken in December 1969 as the white dome was lifted into place. Surrounded by small fountains, the gazebo offers splendid views of the gardens, big lagoon, and canals. (Courtesy Cypress Gardens.)

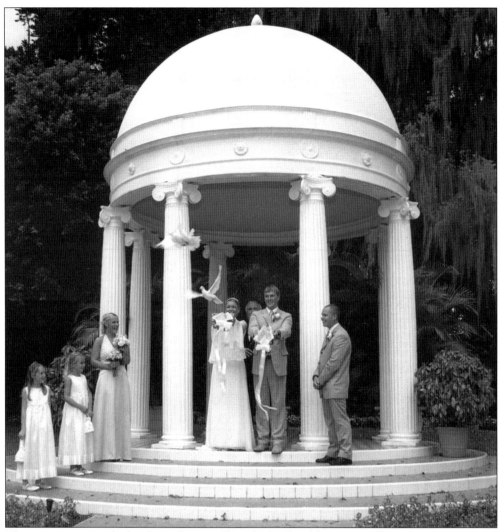

The picturesque gazebo has been the site of hundreds of weddings annually, and it is not unusual for weekend visitors to happen upon a wedding ceremony. According to park booklets from the 1970s and 1980s, the Popes had long envisioned a centerpiece such as this for the botanical gardens. This photograph dates from September 2002. (Courtesy Cypress Gardens.)

The gardens feature thousands of varieties of flowers and flowering plants collected from around the world. Among the earliest planted were many roses, gardenia, camellia, croton, angel trumpet, lily, poinsettia, bird of paradise, orchid, flame vine, hibiscus, bougainvillea, shrimp plant, and bottle brush. From the park's inception, visitors could purchase guidebooks illustrating and describing the magnificent gardens. (Courtesy Cypress Gardens.)

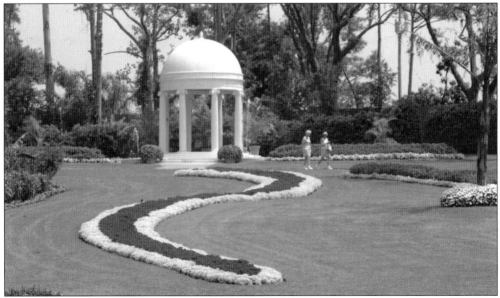

The sudden closure of Cypress Gardens in April 2003 left many questions for the community, and one concern centered on the fate of the historic botanical gardens. Most damaging to the gardens were three 2004 hurricanes, which thinned the foliage and destroyed large trees. Luckily, with some intermediate maintenance, the prize plantings fared well, and when the park reopened, they required immediate—but basic—care. This 2006 photograph illustrates the effect of hurricane damage on trees behind the wedding gazebo. (Courtesy Cypress Gardens.)

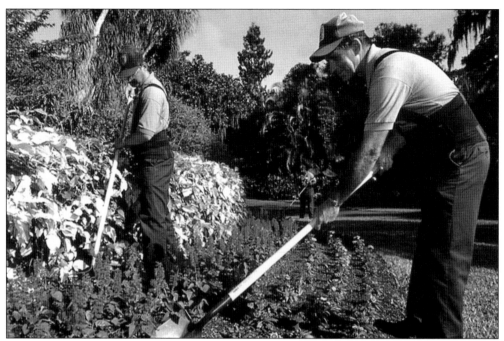

Gardeners tend to the botanical gardens' floral displays in this image, dated 1994. The plantings require constant careful attention, and by 1986, the park was supported by an onsite 40,000-square-foot greenhouse and a 7-acre plant nursery, both at the site of the present visitor parking lot. The facility produced more than 300,000 plants for use in gardens during 1985. (Courtesy Cypress Gardens.)

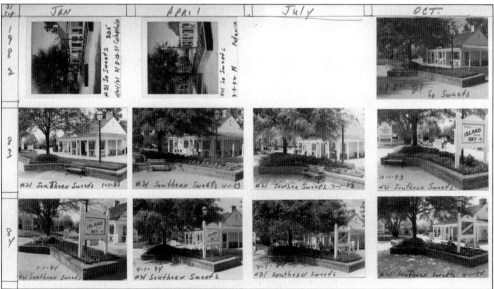

One method of recording seasonal plantings and yearly plant growth was creation of a series of photo boards. These were not meant to be fancy, but they were vitally important to horticulturalists. Looking back now, they document evolving plant color schemes and signage changes. This example documents plantings near the present-day Sunshine Sky Adventure. (Courtesy Cypress Gardens.)

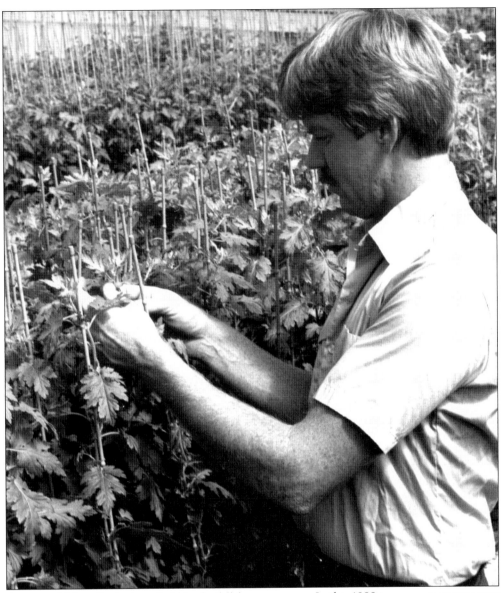

An annual Mum Festival was held in the fall for many years. In this 1988 image, nursery manager Gary Smith checks the progress of staked chrysanthemum plants shortly before they were transferred to larger pots. Mums were trained to cascade in preparation for festival displays. The gardens maintained sizeable greenhouse space and employed a large horticultural staff, including vice-president of horticulture Norm Freel, who worked at the park for two decades. Best known during the 1990s was chief horticulturalist Joe Freeman. He was host of the nationally syndicated television program *Backyard America* and wrote a column answering questions concerning all plant-related issues. (Courtesy Cypress Gardens.)

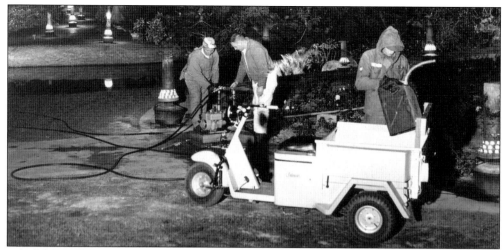

Hundreds of grove heaters have been maintained at the park to ward off the disastrous effects of cold weather; this January 1958 photograph shows gardeners preparing to combat freezing temperatures. Local historian Louise Frisbie recounted: "A few mornings after Florida's disastrous 1962 freeze, the minister from Pope's church visited the apparently unscathed gardens and commented, 'The Lord certainly has taken care of you.' 'Yes, he has,' Pope replied. 'We put our faith in the Lord, put oil in the pots, and fired to beat the Devil.' " (Courtesy Cypress Gardens.)

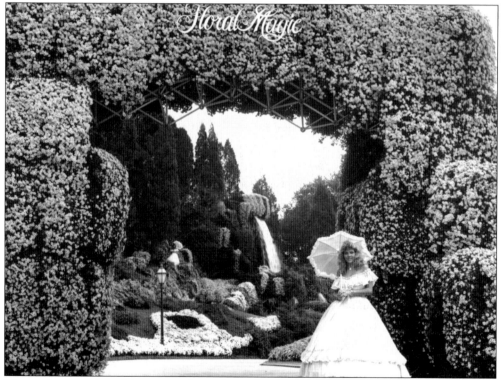

The southern portion of the present-day park was developed between 1972 and 1986. This 30-foot-tall floral entrance to the Gardens of the World was just south of the ski stadiums and was first erected for the November 1985 "Floral Magic: Chrysanthemums on Parade" display. (Courtesy Cypress Gardens.)

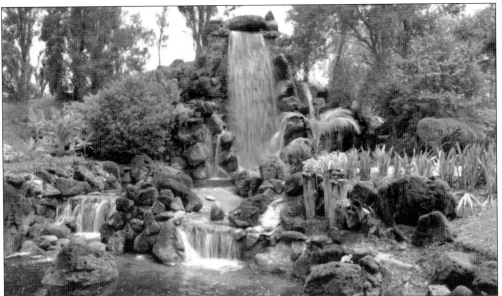

The 40-foot-tall Mediterranean Falls is the largest feature of the Gardens of the World. Seven thousand gallons of water cascade from the flower-draped crest of the falls every minute and pass through a winding riverbed lined with exotic plants. To the south of the falls is the ornate Italian Fountains, covered by 10,000 handmade tiles. The Gardens of the World formerly included a windmill and an enormous 20-ton sundial, crafted by noted resident artist Attilio G. Puglisi. (Courtesy Cypress Gardens.)

Before Cypress Gardens Adventure Park brought the Citrus Line Railroad to life, park guests could only experience railroading in miniature—first through Whistlestop USA and then an elaborate G-scale outdoor layout at the base of the Island in the Sky, shown here in 1997. The outdoor layout included bridges made of natural materials, tunnels, and European-style buildings. G-scale trains were also integral to displays in the FloraDome when it opened in March 2001. (Courtesy Cypress Gardens.)

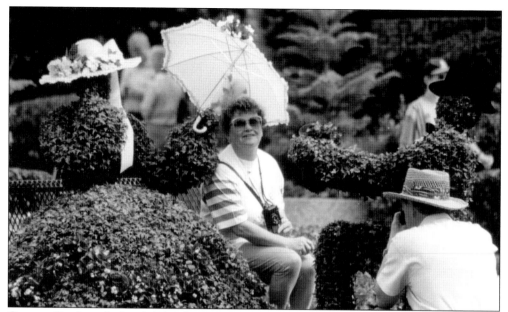

Cypress Gardens declared 1994 the "Year of the Garden" and debuted a large collection of ivy-covered topiary figures designed by Pat Hammer, renowned topiary artist. The figures were installed near the center of the park, north of the Snively Mansion, and offered a whimsical view of the 1860s introduction of tropical flowers to the United States. Among the displays, Victorian figures reenacted a flower show at lakeside, while a topiary horse-drawn wagon passed a topiary carousel; dozens of figures were represented. The exhibit was immensely popular. (Courtesy Cypress Gardens.)

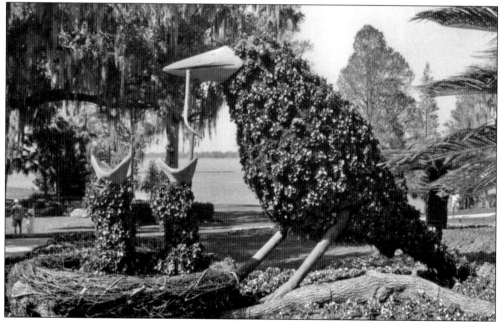

A series of enormous topiary figures still graces the center of the park. Constructed on large metal rebar frames covered with wire mesh and thousands of colorful flowers, the figures include a peacock, swan, caterpillar, rabbit, and other well-crafted creations. (Courtesy Cypress Gardens.)

Four

WATER-SKI CAPITAL OF THE WORLD

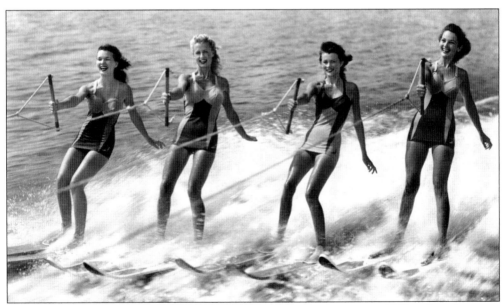

Visitors to Cypress Gardens have been treated to fabulous ski shows since 1947—when they were added to the park's regular offerings—featuring the Aquamaids, who helped popularize water-skiing throughout the Southern states and the nation. From left to right, Nance Stilley, Johnette Kirkpatrick, Patty Colin, and Katy Turner, shown here sporting the latest Jantzen suits, were among the first regular show skiers at Cypress Gardens. (Courtesy Cypress Gardens.)

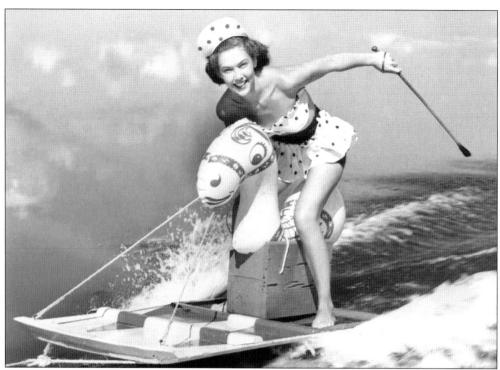

Was there anything Martha Mitchell did not do well? During her time at the gardens, she was a pageant queen, model and belle, champion skier, and adventuresome stunter. This 1953 United Press photograph shows her on a speeding aquaplane astride an inflatable mount. (Authors' collection.)

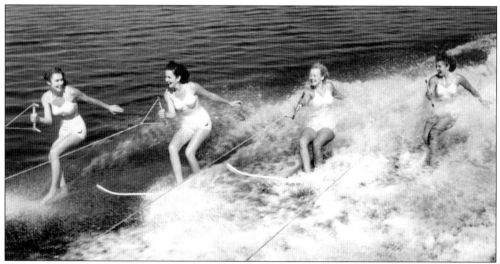

The third annual Dixie Water Ski Tournament was held during April 1949 at Cypress Gardens. This promotional photograph shows four champion water-skiers, listed from left to right: "Martha Mitchell of Winter Haven, Florida champion; Katy Turner of Miami, former national jumping titleholder; Willa Worthington of Oswego, OR, three-time national champ, and Joan Ryan of Buffalo, NY, intercollegiate titleholder." The Dixie Water Ski Tournament developed into one of the nation's oldest and most prestigious. (Authors' collection.)

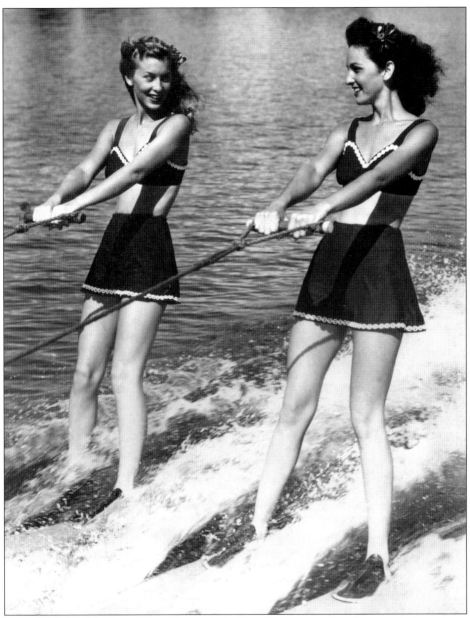

Barbara Chambliss (left) and Katy Turner (right) hit the water in this photograph from the mid-1940s. Chambliss was an accomplished water-skier and covergirl. Her sisters Sylvia and Lucy (a noted marksman) also worked at the park. Sylvia performed in the second ski show held at the park in 1943, and as a 17-year-old, Lucy Chambliss worked as an extra in the 1948 movie *On an Island with You*. In time, Cypress Gardens attracted attention as a water-ski mecca, and both the 1950 and 1957 World Water Ski Championships were held at Cypress Gardens. In 1950, the final standings for men were: first, Dick Pope Jr.; second, Claude DeClercq; and third, Guy DeClercq. The women ranked: first, Willa Worthington McGuire; second, Johnette Kirkpatrick; and third, Evie Wolford. In 1957, the men finished: first, Joe Cash; second, Simon Khoury; and third, Mickey Amsbury. Standings for the women were: first, Marina Doria; second, Leah Marie Atkins; and third, Nancie Rideout. (Courtesy Cypress Gardens.)

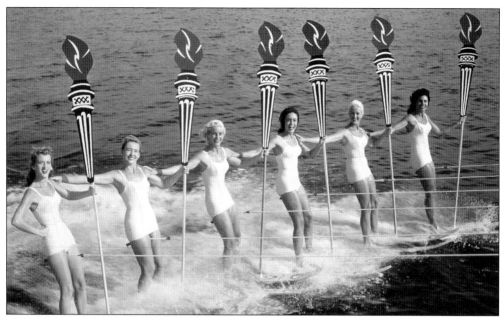

A lovely lineup of Aquamaids skis during the early 1960s. By this time, Cypress Gardens had become one of the preeminent training grounds for championship skiers. Many of the ski team members were in their 20s and were either full-time employees or worked during holidays or summers while attending college. (Courtesy Cypress Gardens.)

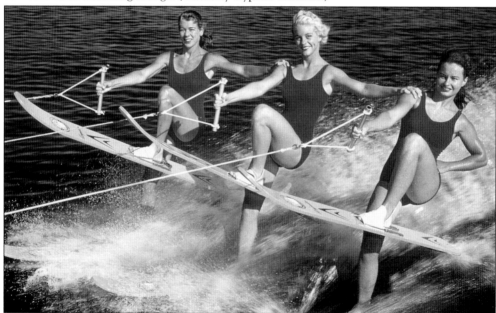

From left to right, Judy Rosch, Barbara Cooper Clack, and Janelle Kirtley skied at Cypress Gardens in the 1960s. Cooper Clack in 1964 became the first woman to ski jump more than 100 feet. She was the 1965 Slalom World Champion, skied the senior tournament circuit through 1980, and as Barbara Cooper Clack Heddon was inducted into the Water Ski Hall of Fame in 1986. Kirtley was the 1961 Slalom World Champion, winning a bronze medal in the overall standings, and received an Award of Distinction from the Water Ski Hall of Fame in 2001. (Courtesy Cypress Gardens.)

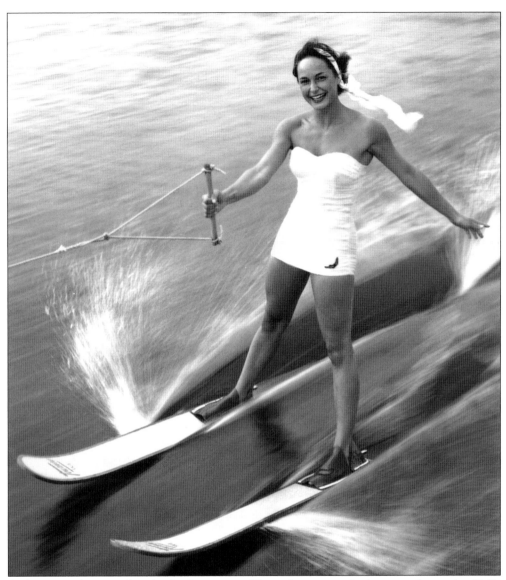

A glamorous Aquamaid smiles for the camera. The earliest water-ski show was the result of Julie Pope's resourcefulness. Dick Pope Jr. recalled in 2006: "One particular day a group of soldiers came to the park and asked my mother when the ski show would take place. She answered without hesitating, '3:30 pm.' She then contacted our school and arranged for my sister and me to leave at 3:00 pm. We then joined with our friends and presented that first ski show." The first ski show performers were Buddy Boyle, Adrienne Pope, Dick Pope Jr., and Ruth Recker. Trammell Pickett was the boat driver. The next weekend, 800 soldiers arrived to watch the ski show, bringing gasoline for the motorboat; rationing was an issue even for Cypress Gardens. An additional troupe of skiers was assembled, including Barbara Chambliss, Sylvia Chambliss, Pat Conlin, Charlotte Cook, Robert Harmon, Bill Hatfield, Tee Matthews, Marvin Phender, Frank Pierce, Pat Riley, Charlie Wolf, Jack Yarborough, Joe Yarborough, and Veda Yearwood. (Courtesy Cypress Gardens.)

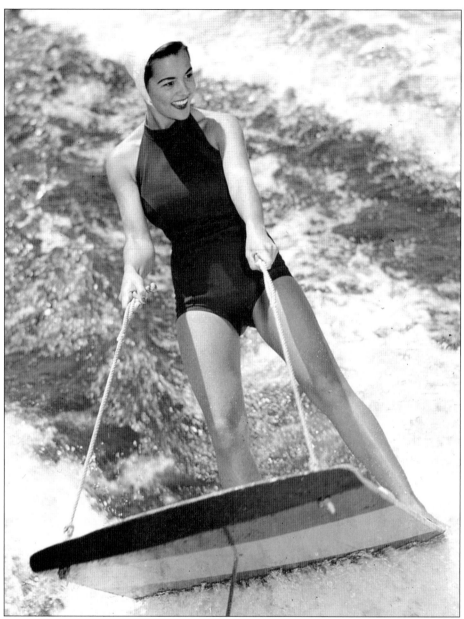

Frances Layton Pope, a former Citrus Queen, demonstrates aquaplaning in the 1960s. She performed in the ski shows before marrying Dick Pope Jr. Her husband recalled that, "Cypress Gardens was a 'family.' Not just my family but our dedicated employees as well. We worked together for the good of the park. As my father stepped back from day-to-day operations it seemed natural and comfortable as I assumed responsibility. We continued to work as a 'family team' until the park was sold in 1985." Dick Pope Sr. commented in 1959: "The entire place is one of the outstanding examples of a family operation. Jack Watkins, Jr., my son-in-law, is general manager. Dick, Jr. is vice president and president of Cypress Gardens Skis, Inc. Mrs. Pope is my right hand. My brother Malcolm and his wife Mimi run the boats and gift shop. My sister, Inez Hallinan, is a real botanist; she talks to all of the leading horticulturists who come in here. Her son, Dennis, is our chief photographer." (Courtesy Cypress Gardens.)

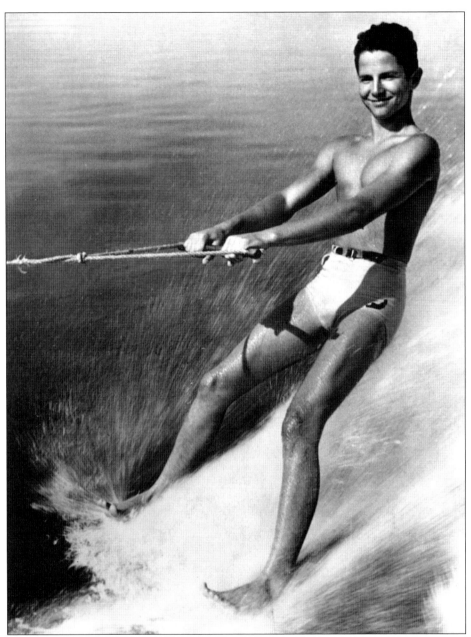

Teenaged Dick Pope Jr. skis on his bare feet at speeds approaching 40 miles per hour. Pope recalled his initial success during a 2006 interview: "A group of us were experimenting with small skis by fastening tennis shoes to boards about 4 1/2" wide by about 13" long. Someone watching us suggested that we try skiing on our bare feet. I decided to try it and Tram Pickett was driving the boat. We were in rough water and I fell. We moved to a calm place on the lake—what we called 'flat water'—and I made it there. My father notified the newspapers and the newsreels and the next thing I knew it was national news." Pope demonstrated barefooting on national television in 1948 and in 1951 was featured in a nationally syndicated sports column, with a cartoon penned by Thomas "Pap" Paprocki. Pope was appointed president of Cypress Gardens in 1962, and he was inducted into the Water Ski Hall of Fame in 1989. (Courtesy Cypress Gardens.)

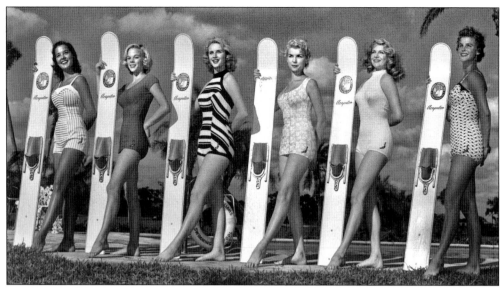

Six skiers model Jantzen swimwear and bright-yellow Cypress Gardens Acapulco water skis on the deck of the Esther Williams Swimming Pool in the early 1960s. Dick Pope Jr. purchased a share in a Lakeland, Florida, water-ski manufacturing company in 1956, and he moved the company closer to Winter Haven when he became the sole proprietor. His company manager, Sanford Fought, was instrumental in many new ski designs, and they produced a diversified line of skiing equipment. (Courtesy Cypress Gardens.)

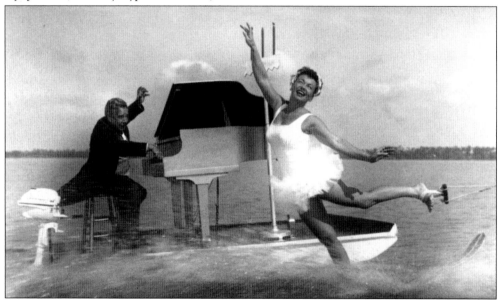

Dick Pope Sr. had a dramatic flair that was virtually unmatched. On several occasions, he was photographed on a large toboggan, topped by a grand piano, pulled by a motorboat. As he sped along, Pope would pose as if playing the piano, and he was usually paired with a dancing skier. His companion in this 1958 picture is the incomparable Willa Worthington McGuire, many-time national and world water-ski champion. She arrived at Cypress Gardens from Oswego, Oregon, in 1948, and after a successful show and tournament career, Willa Worthington McGuire Cook was inducted into the Water Ski Hall of Fame in 1982. (Courtesy Cypress Gardens.)

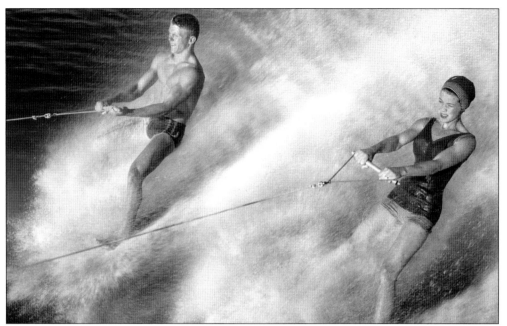

John and Judy Rosch barefoot ski across the waters of Lake Eloise in the 1960s. This spectacular act usually involved taking off on one ski, placing one foot on the water, and then kicking off the ski to place the second foot on the water. Joe Cash, another of Cypress Gardens' most accomplished performers, originated a deepwater take-off in 1957, pulling himself up from the water to barefoot without the use of skis. Barefooting is now a mainstay of Cypress Gardens ski shows, including backward barefooting. (Courtesy Cypress Gardens.)

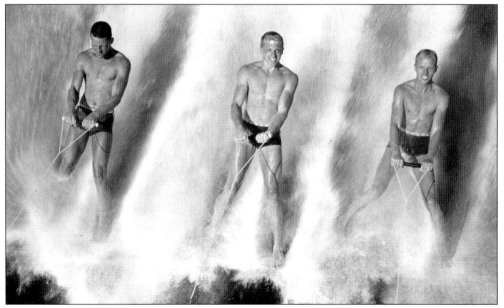

From left to right, Bob Pleas, Joker Osborn, and Fred Knott race across the water sans skis. Other early Cypress Gardens barefooters included Vaughn Bullivant, Ginny Davis, Dave Dershimer, A. G. Hancock (believed to be the first skier to successfully barefoot), Davey Holt, Buster MacCalla, and Alfredo Mendoza. (Courtesy Cypress Gardens.)

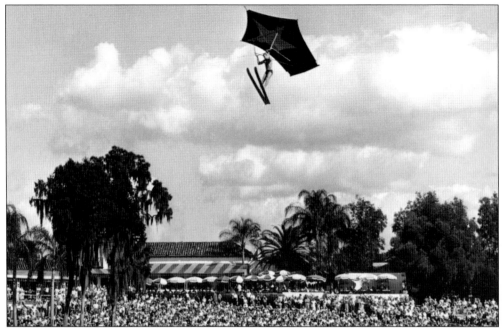

An aerial skier, suspended by a large kite, sails above the crowd during the World Water Ski Championship in September 1957. The water-ski shows have featured kite flying since 1949, first with flat kites and, starting in 1971, with delta-wing kites. Experienced kite fliers are a must, as this part of the show must be timed precisely. Ski show supervisor Mark Voisard is one of the most experienced, having made nearly 15,000 flights between 1977 and 2006. (Courtesy Cypress Gardens.)

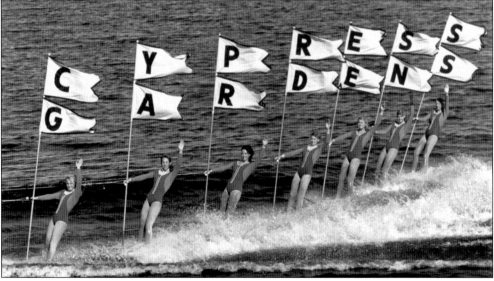

The 1988 rendition was "The Greatest American Ski Show," and it opened like so many had before, with a parade of Cypress Gardens flags. Although there have been a number of changes to the show routine, the basic script Dick Pope Sr. presented in his 1958 book *Water Skiing* feels familiar to longtime park visitors. Popular stars of the show were clowns Corky and Corkette. (Courtesy Cypress Gardens.)

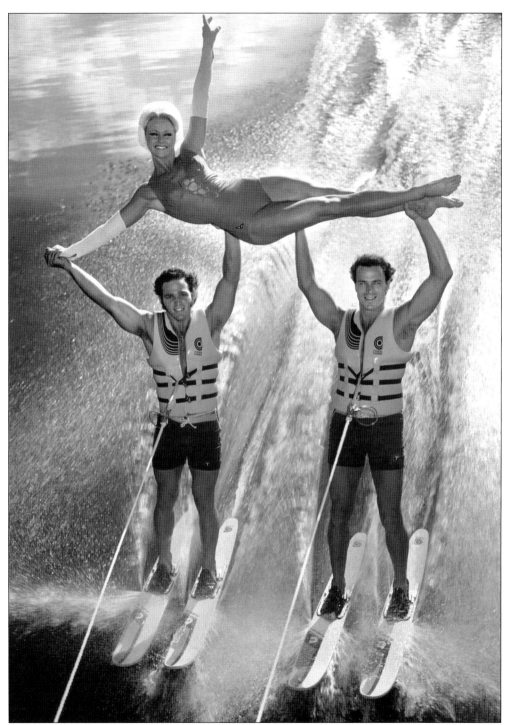

A trio of adagio skiers speeds across Lake Eloise in this undated image. Adagio water-skiing has roots in ballet and ice skating and typically involves two acrobatic skiers performing dance-like lifts and maneuvers over water. Adagio is meant to be graceful, not haphazard, and can be distinguished from early water-skiing stunting or tandem skiing. (Courtesy Cypress Gardens.)

Alfredo Mendoza was one of the most accomplished male water-skiers of the 1950s. In addition to a string of national titles, he won the men's world championships in 1953 in Toronto and in 1955 in Beirut, Lebanon. As testament to his name recognition, and as tribute to his two world championship titles, one model of Cypress Gardens Skis bore his name. Mendoza was also an accomplished ice skater and performed on ice at Cypress Gardens. He was inducted into the International Water Ski Hall of Fame in 1989. (Courtesy Cypress Gardens.)

Lynn Novakofski was part of the Cypress Gardens water-ski shows from 1969 to 1991 and transformed every element of the presentation. He evolved from a respected skier to become the show director in 1974 and entertainment manager in 1986. During that time, he challenged the skiers to develop their technical ability and to practice, practice, practice, emphasizing consistent excellence. He helped develop the four-tier human pyramid, the 360-degree swivel with Betty Bonifay and Sally Winter, strap doubles, and freestyle jumping. In 1989, a performance of the "1969 Water Ski Revue" marked Novakofski's 20th anniversary at Cypress Gardens and helped demonstrate how the sport and the show had evolved under his leadership. Novakofski was instrumental in organizing the 60th anniversary water-skiers' reunion in 2003. (Courtesy Cypress Gardens.)

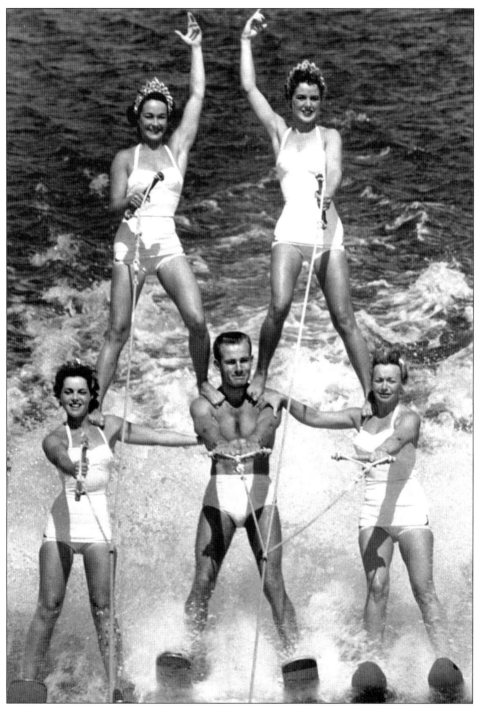

Cypress Gardens skiers first completed a two-tier human pyramid in 1948; this undated image likely dates from the mid-1950s. The human pyramid became a staple of every ski show and is still performed at the conclusion of the presentation. Tandem riding on aquaplanes led to the notion that higher was better, and tandem topside riding—one skier sitting on the shoulders of another—soon followed. (Courtesy Cypress Gardens.)

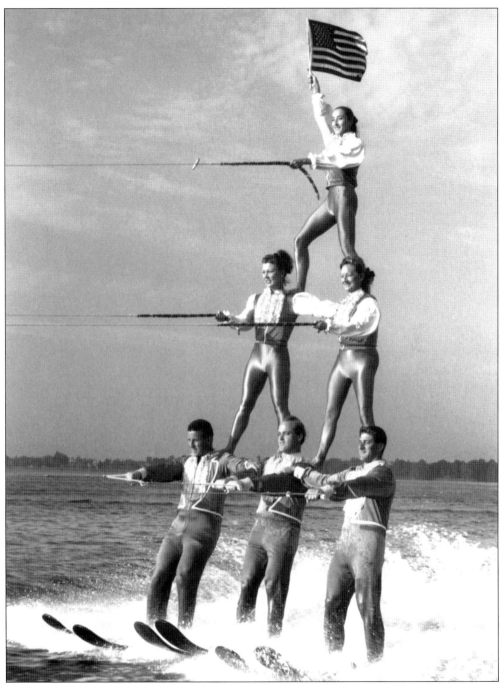

The first three-tiered human pyramid was performed at Cypress Gardens in 1953 and was filmed for the movie *Easy to Love*. Anchored by Bill Hatfield, others who performed this feat were Paul Smith, Bob Cozzens, Red McGuire, Dick Herbert, and Betty Renegar. These days, women usually occupy all of the upper tiers. This three-tiered pyramid appears to be from the 1980s. (Courtesy Cypress Gardens.)

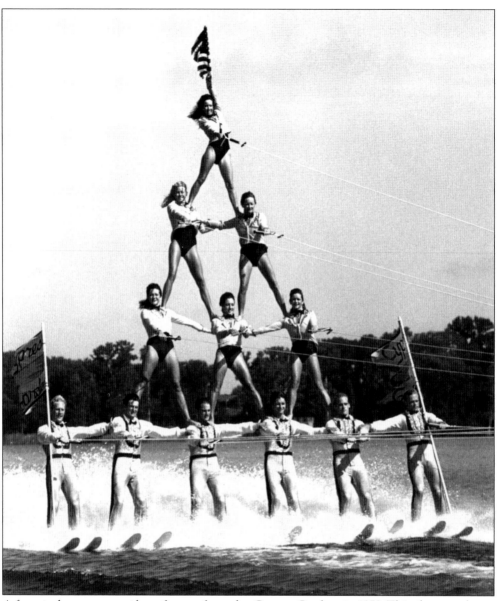

A four-tier human pyramid was first performed at Cypress Gardens in 1979. This photograph was taken in 1987, at a time when the four-tier pyramid was commonly performed at the ski shows. (Courtesy Cypress Gardens.)

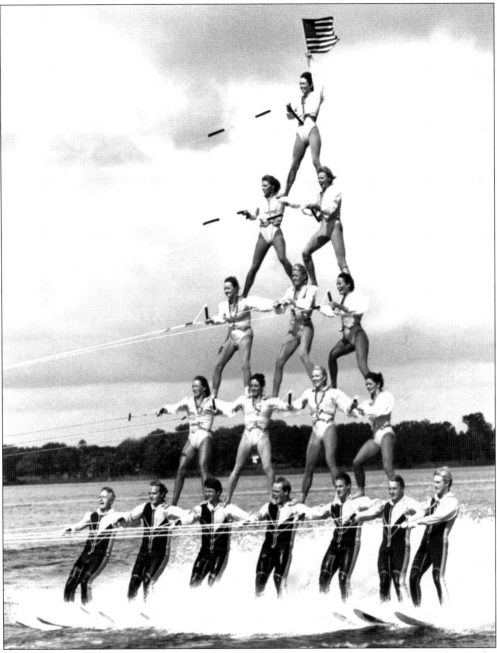

The remarkable five-tier human pyramid was performed for the first time at Cypress Gardens under the direction of Lynn Novakofski in 1986. Recalling the event in a 1989 *Winter Haven News Chief* article, Novakofski admitted, "That is a very hard act which verges on the edge of daredevil. But, we did it and we photographed it for a magazine cover." (Courtesy Cypress Gardens.)

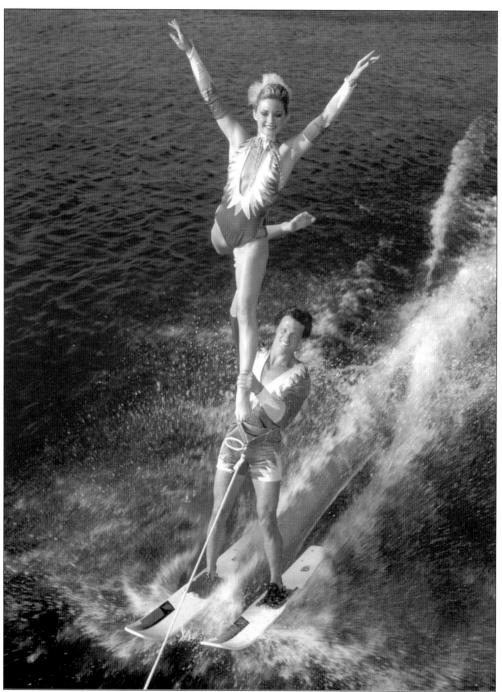

A couple in 1983 performs an adagio routine, also known as strap doubles. In this discipline, the man skis with a strap around his waist attached to the tow rope, so that he is able to freely perform adagio maneuvers with his partner. A twist on this in skills competitions is performance of dry-land adagio doubles, where all of the performance takes place on a stage, rather than on water. Cypress Gardens is renowned for adagio doubles, featuring pairs Linda and Don Buffa and Shaune Stoskopf and Howard MacCalla. (Courtesy Cypress Gardens.)

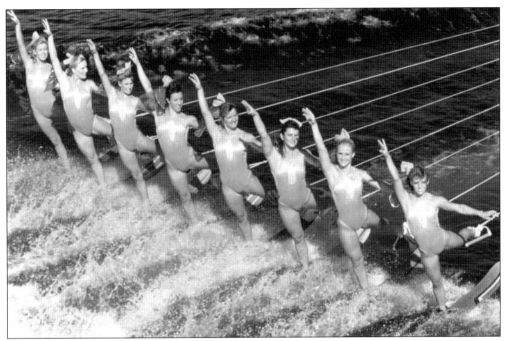

The Aquamaids ballet line performs a routine during the 1980s. Willa Worthington brought her athleticism and dancing ability to the water-ski show in the 1940s and 1950s, along with costume design talents. She coordinated the first ballet line in the show and, with the swivel binder, transformed women's show skiing. Her chapter in Dick Pope's *Water Skiing* discussed group ballet routines. (Courtesy Cypress Gardens.)

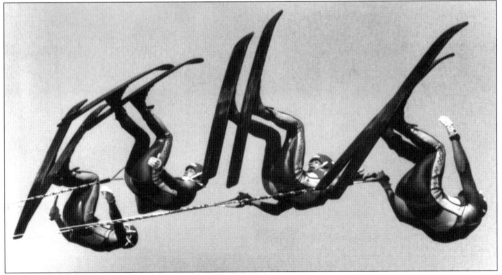

In 1991, the Cypress Gardens Rampmasters performed daring stunts daily in the tropical-themed show "Ski! Ski! Ski! Everybody's Skiin' Caribbean." Billed as part of "America's Greatest Ski Team," the Rampmasters were joined by barefooters, slalom skiers, a four-tier human pyramid, and a lineup of Aquamaids in neon-colored costumes performing to an original music score. A daring world-record nine-man front flip was first accomplished at Cypress Gardens in 2000. (Courtesy Cypress Gardens.)

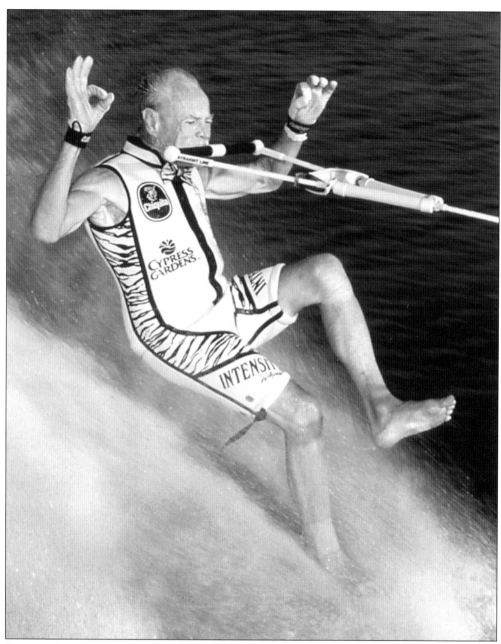

Born in 1915, "Banana" George Blair is one of the best-known water-skiers at Cypress Gardens. Blair learned to ski at the age of 40, learned the art of barefoot skiing six years later, and eventually water-skied across waters on all seven continents. His trademark—besides a love for bananas and the color yellow—became barefooting with the tow rope in his mouth, as seen in this undated image. Banana George celebrated his 91st birthday in January 2006 with a barefoot run at Cypress Gardens Adventure Park, and on that occasion, he was named "Mayor of Cypress Gardens," complete with a reserved parking space. Banana George is a member of the Water Ski Hall of Fame and has been featured in the *Guinness Book of World Records* for his exploits. (Courtesy Cypress Gardens.)

Five

BOATING AT CYPRESS GARDENS

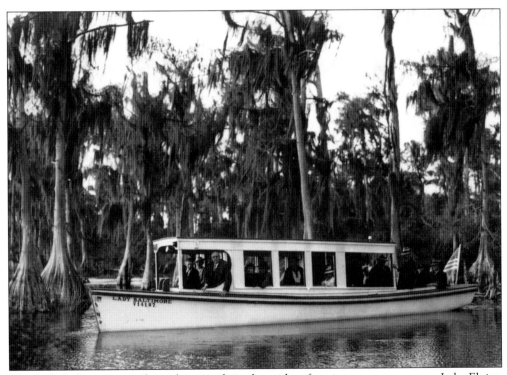

The *Lady Baltimore* stops for a photograph in the midst of ancient cypress trees on Lake Eloise, along the western edge of the botanical gardens north of the clubhouse. Sightseeing boats such as this provided a unique view of Cypress Gardens for early visitors. In 1938, smaller electric boats were brought to the gardens, permitting inland navigation through hand-dug canals. (Authors' collection.)

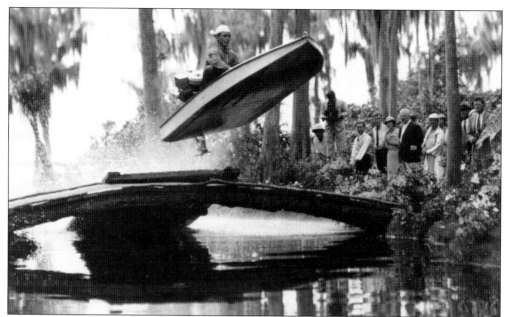

A confident Bob Eastman flies through the air to the delight of spectators in Cypress Gardens in the late 1930s. Steeplechase racers and stunt drivers in small outboard motorboats made regular runs through the canals and between the majestic cypress trees. Eastman was captain of the International Nautical Stunt Team and a star of the 1937 Grantland Rice Sportlight feature *Aquabats*. He was technical advisor and director of the water-ski scenes in *Easy to Love* and served the park in a public relations capacity from 1949 through February 1955. (Authors' collection.)

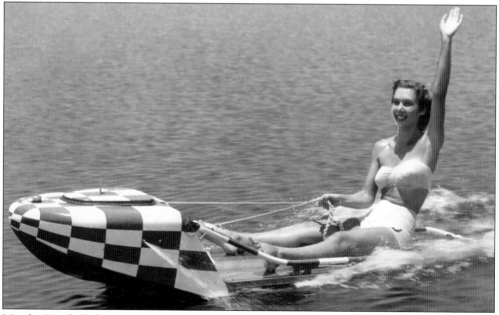

Martha Mitchell drives a motorized aquaplane in this promotional photograph from July 1949. The craft reached speeds of 30 miles per hour and may be viewed as an early prototype of personal watercraft. Captivating images such as this were distributed to media outlets across the country, an effective low-cost, high-visibility marketing tool. (Authors' collection.)

Malcolm Pope was the brother of Dick Pope Sr. and a national outboard motorboat champion. He was credited as the first to jump an outboard—albeit accidentally—during a 1927 race in Palatka, Florida. Much of the early newsreel footage of Cypress Gardens features Malcolm Pope performing spectacular steeplechase stunts in specially constructed boats through flames, over ramps, and from lagoon to lagoon over land. For a number of years, he operated the electric boat concession at the gardens, and his wife, Mimi, ran the gift shop. (Courtesy Cypress Gardens.)

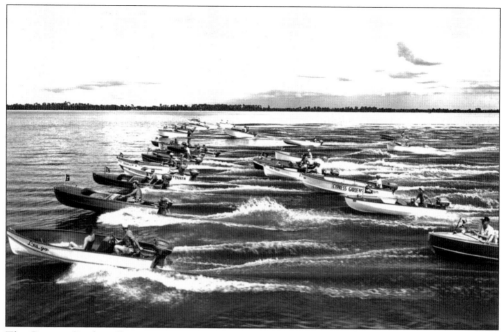

The Cypress Gardens fleet races across Lake Eloise in the early 1950s. Water-ski boats, steeplechase boats, and pleasure craft form this impressive display. (Courtesy Cypress Gardens.)

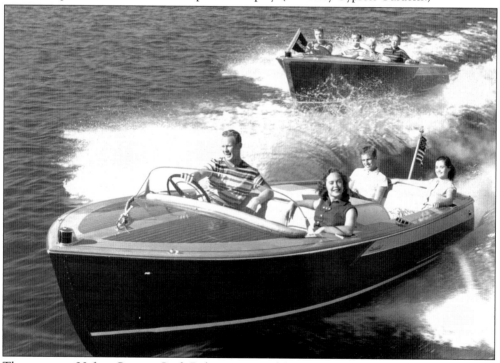

The gorgeous 20-foot Correct Craft Debonnaire model in the foreground was photographed at Cypress Gardens for the Orlando-based manufacturer's 1956 catalog. Additional images for the catalog showed the newly created Tropical Isles of Movieland. The catalog byline promoted Cypress Gardens as a vacation destination at little cost to the park. (Courtesy Cypress Gardens.)

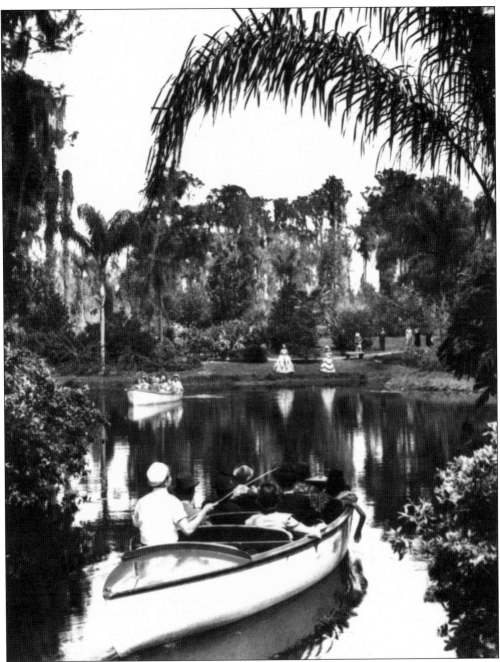

A January 1938 *Winter Haven Herald* article announced an innovation at Cypress Gardens: "New to Florida this year is the fleet of quiet electric boats which will fly silently through the tropical lagoons of the Florida Cypress Gardens near Winter Haven. From these boats the beautiful scenery of this show place is presented to the visitor as a moving panorama displaying the natural beauty of Florida, 'The land of sunshine and flowers.'" As a youngster, Dick Pope Jr. and his friend Buddy Boyle were among those who piloted tourists through the canals, describing the plant life. A scene from the 1941 *Moon Over Miami* movie showcased these electric boats. (Courtesy Cypress Gardens.)

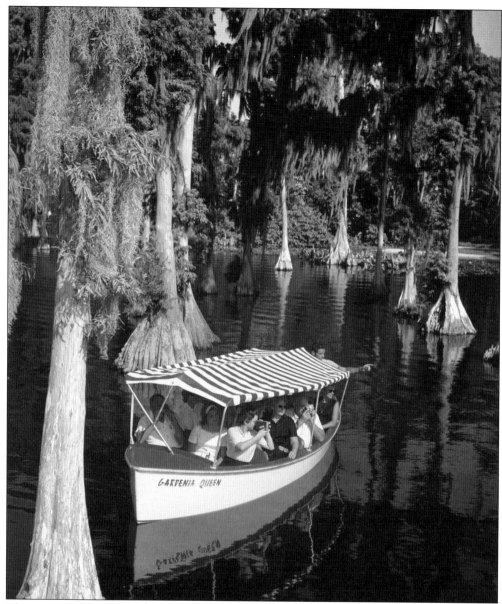

The covered *Gardenia Queen* passes through the park's ancient Spanish moss–draped cypress grove during the 1950s. Bald cypress, a member of the pine family, grows to be 50 to 70 feet tall and grows best in shallow water or swampy soil. They are characterized by wide bases and horizontally spreading roots. From these roots extending upward are distinctive "knees," the exact purpose of which is unknown. The fine fern-like leaves are dropped during winter, but the trees soon renew their green foliage. The cypress trees posed a hazard during filming of *Easy to Love*, as reported by the *Winter Haven Herald* in February 1953: "A camera crew boat crashed head-on into a cypress tree, dumping the crew, cameras and other equipment into Lake Eloise. Injured and taken to the Winter Haven Hospital were Harold Lipstein and John Schmitt, cameramen. Others in the craft were not injured. Officials said that all the equipment was recovered and that the film, used in the day's shooting, may still be good. It was rushed in special containers to Hollywood for a check." (Courtesy Cypress Gardens.)

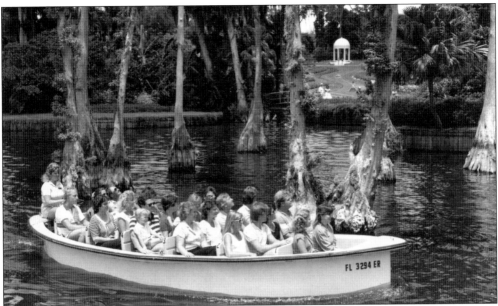

An electric boat tour in the late 1980s passes the often-photographed wedding gazebo. The narrated tours through the garden canals lasted approximately 30 minutes. In addition to the cypress trees, other hearty species include the saw palmetto, dahoon holly, Australian pine, live and water oaks, yellow pine, date and cabbage palms, magnolia, gordonia, and wax myrtle. (Courtesy Cypress Gardens.)

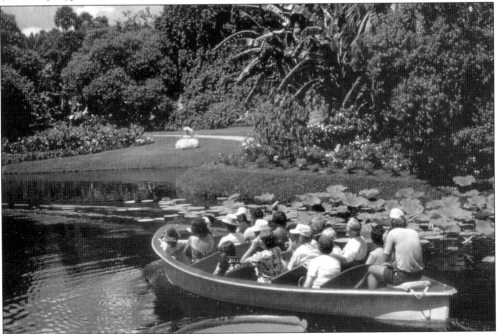

A 1980s electric boat passes spectacular Victoria water lilies in the big lagoon. During this time, belles rotated between 11 locations throughout the park, staying at each location for 20 minutes until replaced by another belle. Their shift lasted nearly an hour and a half, after which time they returned to their dressing rooms to prepare for another shift. (Courtesy Cypress Gardens.)

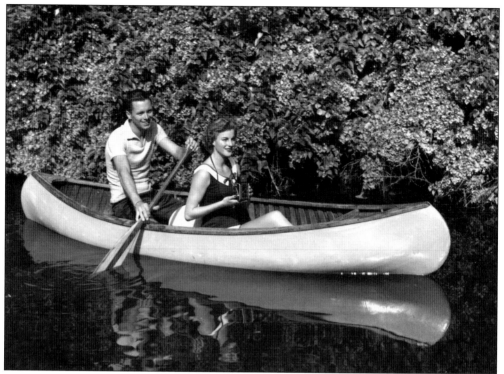

Electric boats were not the only mode of transportation. This publicity photograph shows a wood and canvas canoe carrying a young couple through the gardens in search of photogenic landscapes. They doubtless found many to choose from. (Courtesy Cypress Gardens.)

You never know what you'll see at Cypress Gardens. These passengers seem confident in their canine pilot speeding along Lake Eloise in 1987. (Courtesy Cypress Gardens.)

In what seemed a return to Cypress Gardens' roots as a dynamic boating showplace, this July 1980 Pabst Blue Ribbon beer commercial featured daring motorboat jumping. It had been over four decades since Bob Eastman and his International Nautical Stunt Team had performed similar high-flying stunts. (Courtesy Cypress Gardens.)

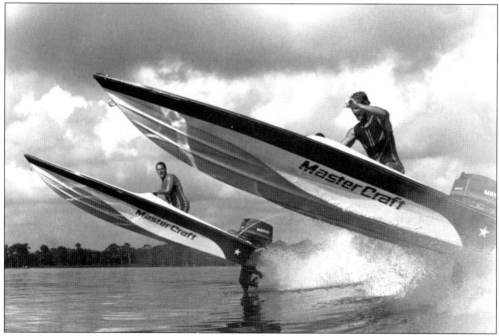

MasterCraft established a sponsorship with Cypress Gardens in the early 1970s, providing the sleek motorboats featured in the world-famous water-ski show. These mid-1980s boats were powered by Mariner outboard motors. (Courtesy Cypress Gardens.)

Cypress Gardens has sponsored many special events on and above Lake Eloise. This 1991 boat race was one of many regattas held at the park over the past seven decades. Especially popular during the 1970s were ski kite flying competitions, where competitors soared hundreds of feet above the crowd, performing exacting routines. (Courtesy Cypress Gardens.)

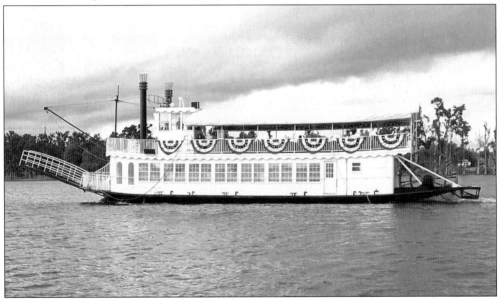

The *Cypress Belle* paddleboat, introduced in February 1999 by Espen and Shelly Tandberg, provides sightseeing excursions and dinner cruises. Previously known as the *Southern Breeze*, the 108-foot-long paddleboat is a replica of riverboats that once traveled along the Mississippi River. The boat is just narrow enough at 22 feet to pass through the canal connecting Lakes Eloise and Summit. The paddleboat remained operational when Cypress Gardens closed in 2003, and it continues to delight passengers. (Courtesy Cypress Gardens.)

Six

MOVIES AND TELEVISION

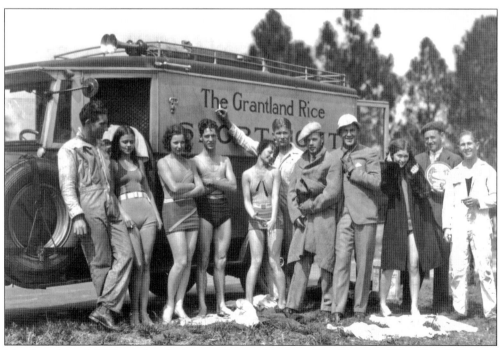

March and April 1937 were heady times at Cypress Gardens. The Grantland Rice Sportlight crew was in town to film *Aquacades*, a two-reel thriller featuring "outboard motor daredeviltry and aquaplane trickery." Dick Pope Sr. directed; Malcolm Pope, Carl Bryson, Rabbit Holland, and Bob Eastman's International Nautical Stunt Team performed with a large crew. The film debuted at Winter Haven's Ritz Theatre on July 31 with great fanfare. (Courtesy Cypress Gardens.)

It is March 1941, and a Twentieth Century Fox crew is completing work on *Moon Over Miami*, the first feature film to highlight beautiful Cypress Gardens. Several extended scenes were filmed on location, including exciting boat racing through the canals. The all-star cast included Don Ameche, Betty Grable, Robert Cummings, Carole Landis, Jack Haley, and the incomparable Charlotte Greenwood. Doubles were used in the local filming of *Moon Over Miami*, with close-ups and dialogue shots completed in Hollywood. The movie credits Cypress Gardens as the site of "puddle-jumping" scenes. (Courtesy Cypress Gardens.)

The unmistakable Cypress Gardens clubhouse is visible in this action shot photographed during the filming of *Moon Over Miami*. Doubles for Robert Cummings and Betty Grable are being pursued by a second boat with the double for Don Ameche, leading to a spectacular jumping sequence. (Courtesy Cypress Gardens.)

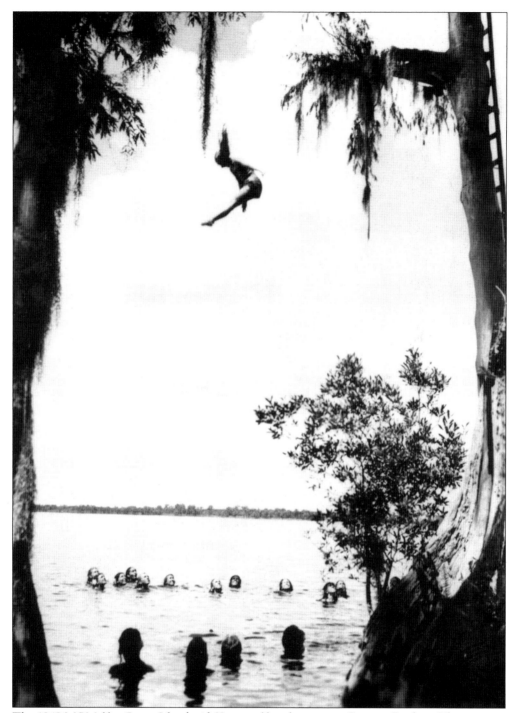

The 1948 MGM film *On an Island with You* was filmed in part at Cypress Gardens. The opening scene features Esther Williams diving from a spectacular cypress, which became known as the Esther Williams Tree. A group of Aquamaids viewed the dive from the water, and the scene continued with a synchronized swimming sequence. The all-star cast included Peter Lawford, Cyd Charrise, Ricardo Montalban, Jimmy Durante, and Xavier Cugat. (Courtesy Cypress Gardens.)

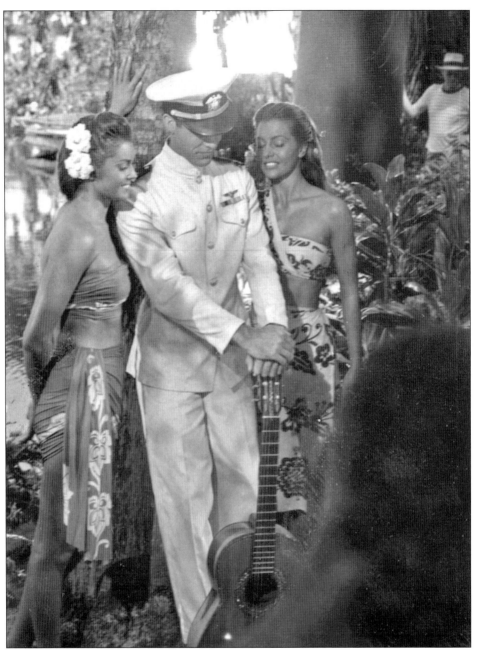

From left to right, Esther Williams, Ricardo Montalban, and Cyd Charisse are photographed during a scene from *On an Island with You*. It is a scene within a scene, as the three played movie actors filming a movie in the tropics. Winter Haven girls taking part in the movie included Clara Brewer, Dixie Byram, Jackie Causey, Lucy Chambliss, Lenore Costello, Jan Cronmiller, Martha Daniel, Judy Davis, Kay DeHaven, Tinka Duggan, Georgia Fisher, Helen Hatfield, Joanne Hickman, Nancy Holland, Jan Jones, Rae Lathers, Helen Layton, Shirley MacCalla, Rita Manchester, Jean Nathey, Julie Patton, Adrienne Pope, Mary Ann Schock, Eleanore Scott, Sammie Stilley, Jane Strickland, Jean Strickland, Bette Tait, Diane Van Dusen, Gene Rae Wile, and Eleanor Williams. (Courtesy Cypress Gardens.)

Scenes for *On an Island with You* filmed at Cypress Gardens were completed in June 1947. Several weeks of filming followed at Anna Maria Beach. This candid photograph of Cyd Charisse was one of a handful donated to the park's archives by Winter Haven's Chrissy Woolley: "Was so thrilled when Peter Lawford set his white shoes on the bench next to this Southern Belle." Charisse's remarkable talents as a dancer were clearly on display in this film. (Courtesy Cypress Gardens.)

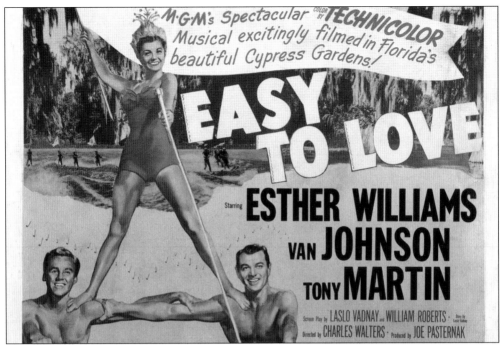

Advertised on this vintage title card as "MGM's spectacular musical excitingly filmed in Florida's beautiful Cypress Gardens," *Easy to Love* brought Esther Williams back to Winter Haven. Van Johnson plays the owner of Cypress Gardens, and Williams is a star Aquamaid. Her attempts to attract his attention are played out through the film. A glimpse of mid-century Cypress Gardens, a series of breathtaking water-ski scenes, and enjoyable synchronized swimming are not to be missed. (Authors' collection.)

Tony Martin croons "Look Out, I'm Romantic" to Esther Williams at the Florida-shaped pool that bears her name. This vintage lobby card gave moviegoers a glimpse of this new landmark. Filming for *Easy to Love* commenced in January 1953, and nearly 10,000 spectators viewed the monumental water-ski finale. Over 100 local high school girls were extras in the film. (Authors' collection.)

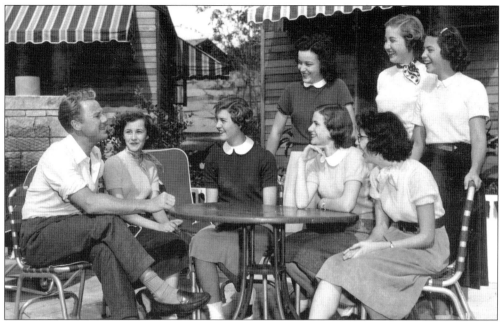

Van Johnson chats with local fans while shooting *Easy to Love*. Johnson and Esther Williams had costarred in four earlier films, including *A Guy Named Joe* (1943), *Thrill of a Romance* (1945), *Easy to Wed* (1946), and *Duchess of Idaho* (1950). (Courtesy Cypress Gardens.)

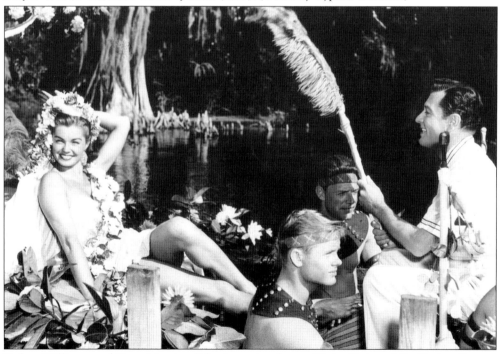

Esther Williams and Tony Martin glide along the shore of Lake Eloise while filming *Easy to Love*. Martin plays one love interest to Williams's character in the film; a brief uncredited cameo at the end of the movie by Martin's real wife, Cyd Charisse, is a treat for astute viewers. (Authors' collection.)

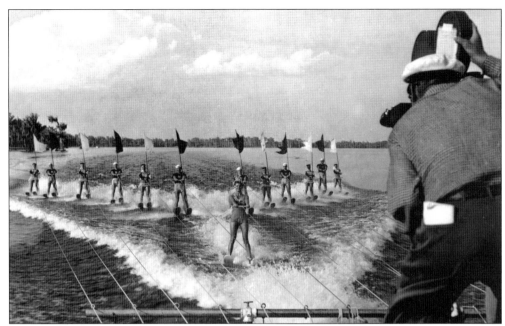

Although pregnant with her daughter Susie, Esther Williams performed most of her own water-ski work in *Easy to Love*—not bad, considering that she had never skied before accepting the role! As part of the grand finale, Williams was to have been lifted from Lake Eloise by a helicopter 80 feet into the air, whence she would dive into the lake. For safety's sake, platform diver Helen Crelinkovich performed as Williams's double for this dramatic stunt. (Courtesy Cypress Gardens.)

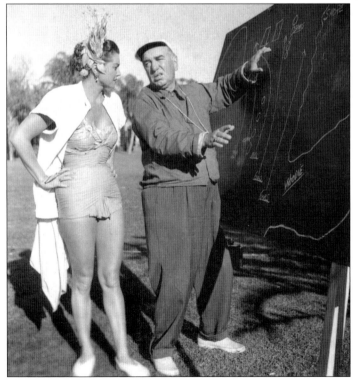

Masterful choreographer Busby Berkeley shows Esther Williams his plans for the grand finale of *Easy to Love*, a legendary water-ski and boating extravaganza. Forty-eight skiers towed by eight boats joined Williams in a seven-and-a-half minute sequence of spectacular skiing and jumping, during which Williams slalomed past six enormous water pumps that sent water 60 feet skyward. This "Avenue of Fountains" required several thousand feet of pipe and fire hose and was operated from shore. (Courtesy Cypress Gardens.)

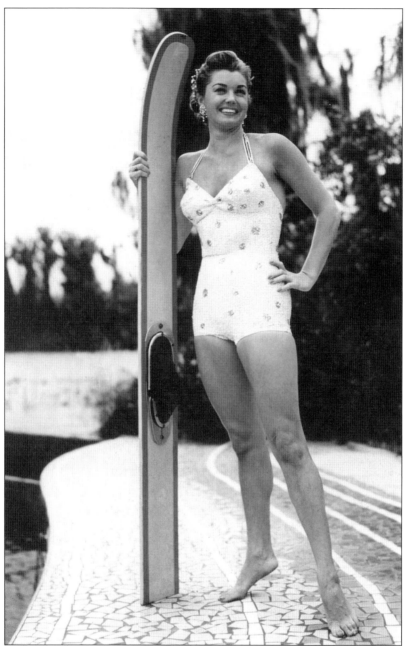

Esther Williams poses on the deck of the Florida-shaped pool constructed for *Easy to Love*. Williams was a teenaged national swimming champion in Los Angeles with dreams of making the 1940 Olympic team. World War II intervened, the games were cancelled, and she embarked on a successful movie career, making 26 films over 20 years. Williams popularized synchronized swimming, and many of her films included elaborate swimming sequences. She was enshrined in the International Swimming Hall of Fame in 1966, not for her swimming prowess, but for her contributions to promoting all forms of swimming for health and exercise. A successful businesswoman, Williams lent her name to aboveground swimming pools and a swimwear collection. (Courtesy Cypress Gardens.)

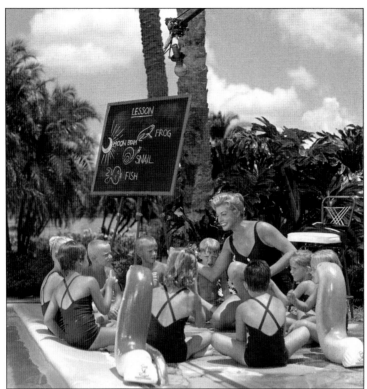

Esther Williams returned to Winter Haven to tape the 1960 television special *Esther Williams at Cypress Gardens.* Costarring with Williams were future husband Fernando Lamas and Joey Bishop. This image shows the popular star speaking with children at the edge of the new Esther Williams pool at the north end of the park. This small rectangular pool was located northwest of the Aquarama pool, also constructed for the special. (Courtesy Cypress Gardens.)

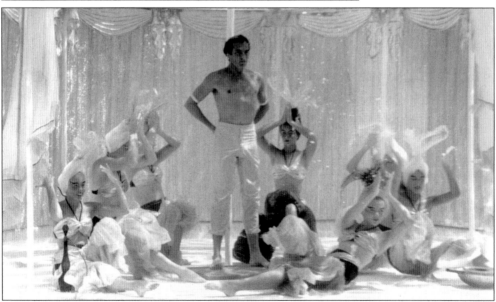

The new Aquarama pool was used to tape underwater sequences for *Esther Williams at Cypress Gardens,* including this scene where Fernando Lamas is surrounded by a beautiful harem. Lamas, a former Argentinean swimming champion, was well-matched with Williams in synchronized swimming in the new pool. The 60-minute musical special, which aired on NBC in August 1960, told the story of a Middle Eastern prince who visits Cypress Gardens with his harem and falls in love with Williams. (Courtesy Cypress Gardens.)

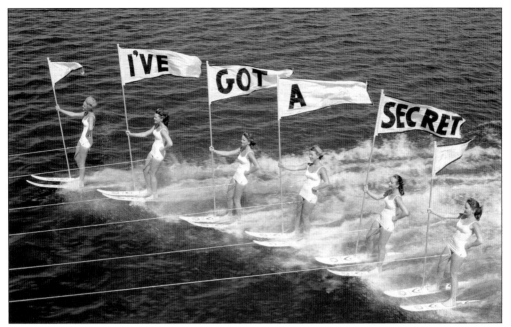

Cypress Gardens Aquamaids announce the arrival of the popular *I've Got a Secret* television show to Winter Haven. Moderated by Garry Moore, four panelists attempted during rounds of questioning to discern a guest's secret. The show also included talent skits or demonstrations. (Courtesy Cypress Gardens.)

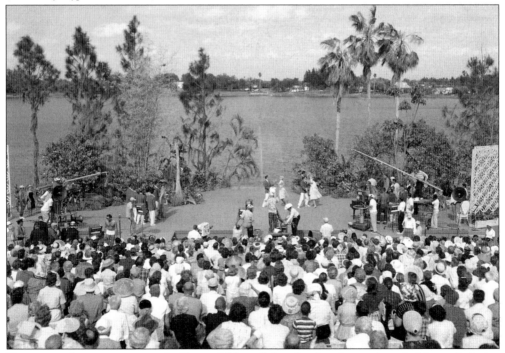

Dancers perform on a stage at the Tropical Isles of Movieland at the north end of the park during taping of a 1961 episode of *I've Got a Secret*. Garry Moore also taped segments at the Florida Citrus Festival in Winter Haven. (Courtesy Cypress Gardens.)

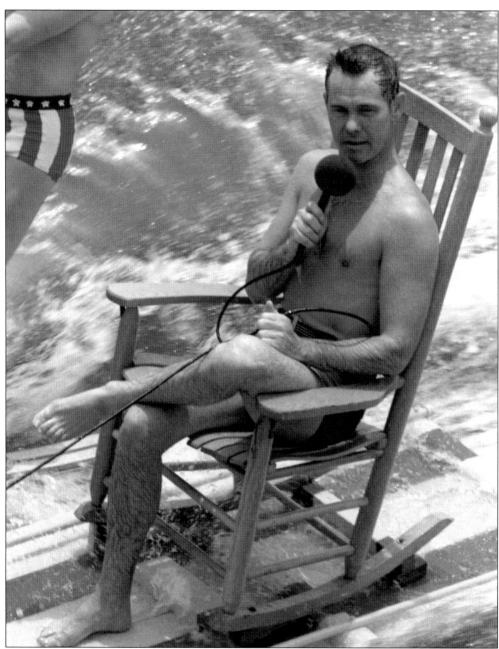

Johnny Carson, longtime host of *The Tonight Show*, was a particularly memorable guest of the gardens. During three days of taping for his September 1968 *Johnny Carson Discovers Cypress Gardens* special, he enthusiastically participated in stunts on and in the water. Carson rode on the shoulders of two skiers, was pulled along Lake Eloise on a bright orange inner-tube at 50 miles per hour, taped underwater sequences in the Aquarama pool, water-skied, rode a flying kite, and climbed aboard a rocking chair bolted to a water toboggan. From that vantage point, while being towed across rough water for over an hour, he introduced water-skiers who pulled alongside. (Courtesy Cypress Gardens.)

Seven

CELEBRITY VISITORS

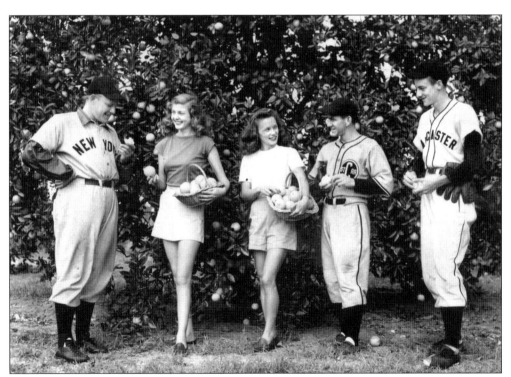

Baseball players who visited the park in 1948 included Ralph Houk, catcher for the New York Yankees (left); third baseman Don Reo of Greenville, North Carolina (second from right); and pitcher George Glick of Rehoboth Beach, Delaware (right). Their hostesses were only identified as Beckey (left) and Ike (center). (Courtesy Cypress Gardens.)

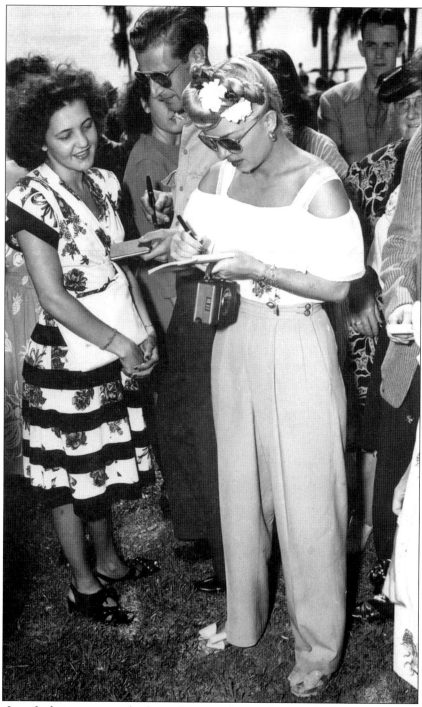

Frances Langford signs autographs for enthusiastic fans at Cypress Gardens after World War II. Langford was best known as a radio and movie performer and USO star; her "I'm in the Mood for Love" was a particular favorite of the troops. Locally she was remembered fondly as a young Lakeland woman with immense vocal talents. Other images taken the same day show Langford photographing a water-ski show and enjoying citrus. (Courtesy Cypress Gardens.)

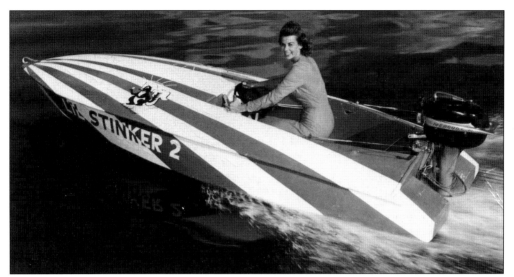

Speed queen Betty Skelton puts the *L'il Stinker 2* through its paces at Cypress Gardens. Skelton was an aviation speed and aerobatics champion, holding more combined aviation and automotive records than anyone else in history. Her famed Pitts Special *Little Stinker* is displayed at the National Air and Space Museum. (Courtesy Cypress Gardens.)

Edith Wilson, as Quaker Oats advertising icon Aunt Jemima, visits with two belles. Wilson first portrayed Aunt Jemima in 1948 and made appearances at shopping centers promoting Quaker Oats products. She also portrayed the character on radio and television over an 18-year association with the company. An early pioneer in African American musical theater and a classic blues singer, Wilson traveled the world with the Sam Wooding Orchestra in the late 1920s, performed with several bands during the 1930s, toured with USO shows during Word War II, and appeared on the *Amos 'n Andy Show*. (Courtesy Cypress Gardens.)

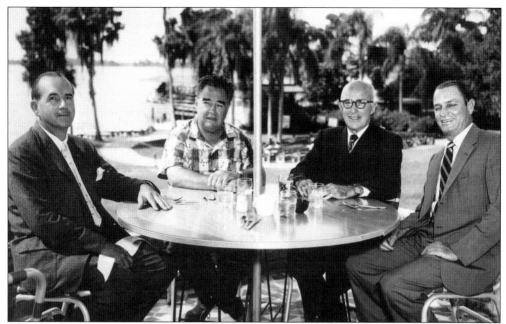

From left to right, George W. Jenkins, Dick Pope Sr., Ludd M. Spivey, and Ben Hill Griffin Jr. were four of the most respected men in Central Florida in 1956. Jenkins was founder of the Publix Super Market chain, Spivey had been president since 1925 of Lakeland's Florida Southern College, and Griffin owned a citrus and cattle empire. Both Jenkins and Griffin served as honorary chancellors for Florida Southern College. (Courtesy Florida Southern College Library.)

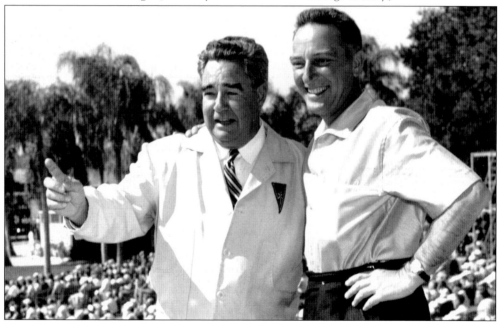

The affable Garry Moore (right) visited with Dick Pope at Cypress Gardens while filming an episode of *The Garry Moore Show* in 1961. Moore enjoyed a long career as a television host, including variety and game shows. He was also a guest on the most noteworthy television shows of the 1950s and 1960s. (Courtesy Cypress Gardens.)

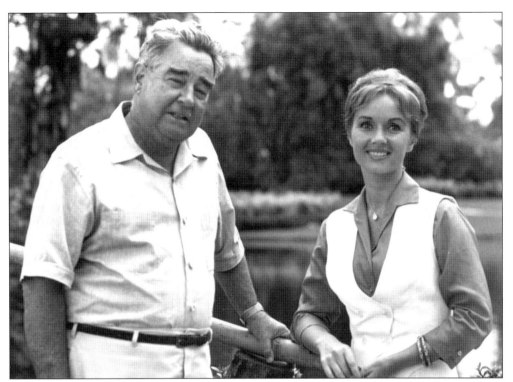

Dick Pope Sr. and Debbie Reynolds pause for a photograph in the 1970s in front of the big lagoon. According to a March 1955 Cypress Gardens employee newsletter, Reynolds was then considered for a short film, *The Cypress Gardens Story*. (Courtesy Cypress Gardens.)

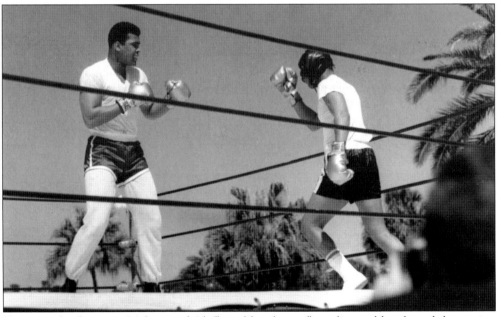

Heavyweight champion Muhammad Ali floats like a butterfly and stings like a bee while sparring at Cypress Gardens in the 1960s. Ali trained in Miami during the early part of the decade, and a number of his earliest fights were staged in Miami Beach. (Courtesy Cypress Gardens.)

Hank Williams Jr. has performed at Cypress Gardens for four decades, including a concert in 2006. This photograph of the multitalented musician was taken adjacent to the Aquarama pool in the early 1970s. (Courtesy Cypress Gardens.)

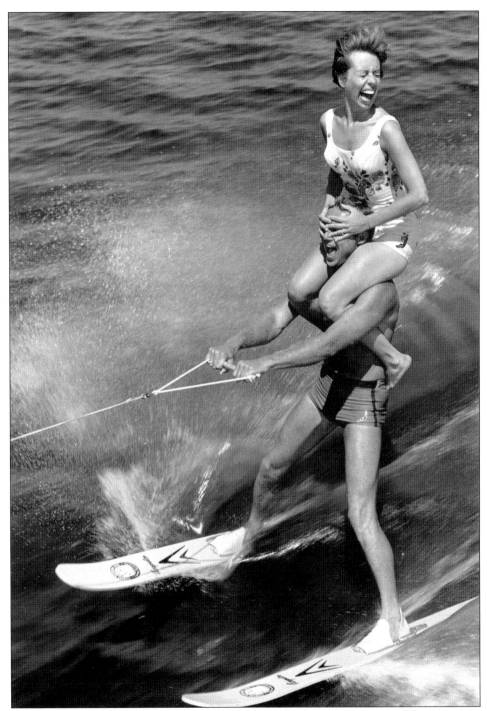

Carol Burnett visited Cypress Gardens during the summer of 1961 for a taping of *The Garry Moore Show*, accompanied by Moore, Peter Lawford, and Alan King. She made a name for herself on the show as a regular from 1959 to 1962 and found later success hosting *The Carol Burnett Show*, which ran for 11 seasons. The comedienne water-skied, spent time at the Aquarama pool, and interacted with fans. (Courtesy Cypress Gardens.)

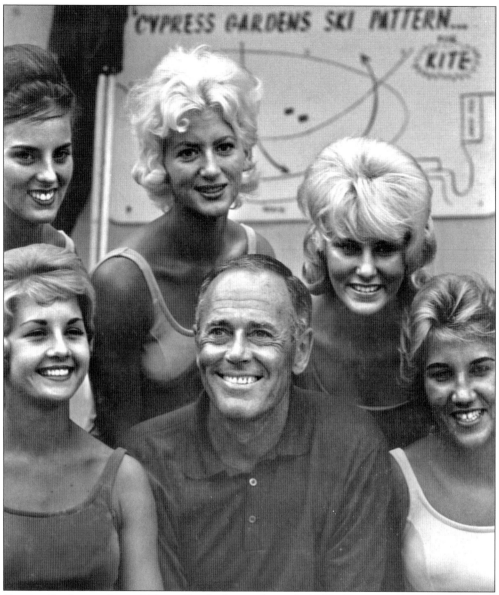

Cypress Gardens welcomed Henry Fonda during the early 1960s. He was in town to crown the Gardenia Queen and is shown here posing with Aquamaids before a water-ski show. Fonda had made more than 50 films prior to his visit and was a top box-office attraction. (Courtesy Cypress Gardens.)

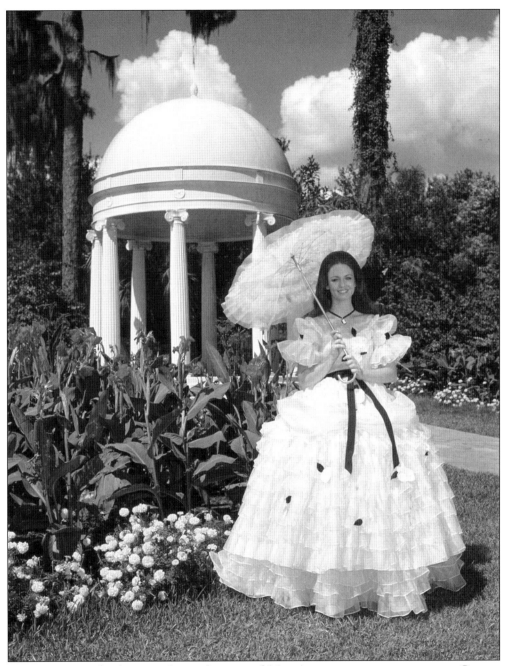

For many years, the first stop for newly crowned Miss America pageant winners was Cypress Gardens. Phyllis George, Miss America 1971, visited the park shortly after her coronation, continuing this long-standing tradition. Among the other Miss America titlists to visit were Lee Meriwether (1955), Marilyn Van Derbur (1958), Mary Ann Mobley (1959), Nancy Fleming (1961), Jackie Mayer (1963), Donna Axum (1964), Vonda Van Dyke (1965), and Pam Eldred (1970). These celebrated visitors posed for publicity photographs, water-skied, and interacted with fans. (Courtesy Cypress Gardens.)

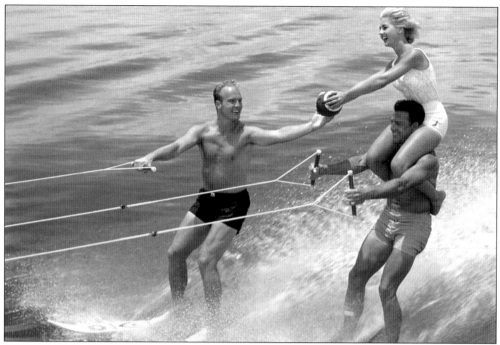

Paul Hornung (left), Frank Gifford (right), and Miss Smile 1963 Gayle Newberry enjoy a friendly game of football on the lake. The 1956 Heisman Trophy winner Hornung starred for the Green Bay Packers, and Frank Gifford enjoyed success with the New York Giants. (Courtesy Cypress Gardens.)

Comedian Tim Conway was in hot water with his fans in the botanical gardens in 1966. Fresh off a successful run on *McHale's Navy*, Conway appeared in the variety series *The John Gary Show* that summer, including scenes filmed in Florida. He later starred in the popular 1970s *Carol Burnett Show*. (Courtesy Cypress Gardens.)

Eight

PARK EXPANSION

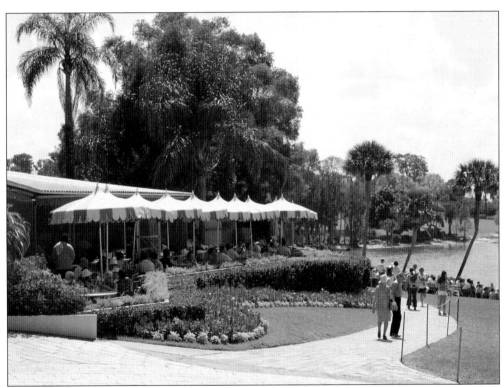

The Palm Terrace Dining Room offered fine dining for park visitors and afforded a marvelous view of the water-ski shows. Construction had started on the second ski arena—not visible from this vantage point—when this photograph was taken in 1973. During the 1950–1951 season, visitors could select one of several complete entrées for $1.75 and enjoy a peach shortcake "with fresh frozen peaches and gobs of whipped cream" for 50¢. All citrus came from the Snively Groves. (Courtesy Cypress Gardens.)

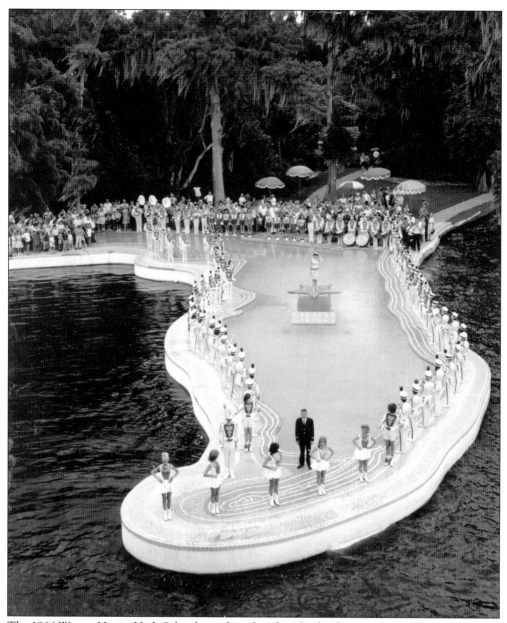

The 1966 Winter Haven High School marching band smiles for the camera at the Florida-shaped Esther Williams Swimming Pool. Cypress Gardens' photographers went to great lengths to get the "perfect shot." According to Neysa Nelms Mazzarese: "Life at the Gardens was 'can do.' For one photo shoot they decided that a cast of thousands with the same costume on skis was what was called for. They gathered up everybody to the take-off dock, all twenty four of us. I told them that I didn't know how to ski. 'Not a problem, it's easy.' I guess the picture looked just as good with twenty three skiers because I barely made it off the dock." (Courtesy Cypress Gardens.)

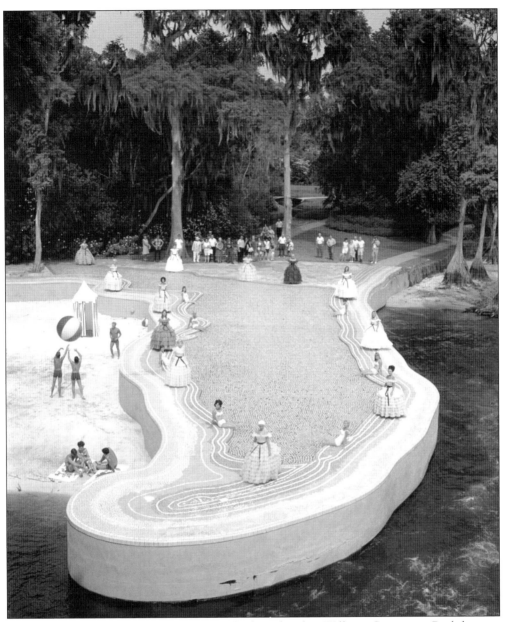

This is a peculiar undated view of the Florida-shaped Esther Williams Swimming Pool showing a sandy beach area to the left. Photographs like this were taken from a tall platform west of the pool, and many different views exist, but without the beach. The pool was used in scores of photo shoots for commercial products, to promote the park, and to promote the Florida citrus and tourism industries. (Courtesy Cypress Gardens.)

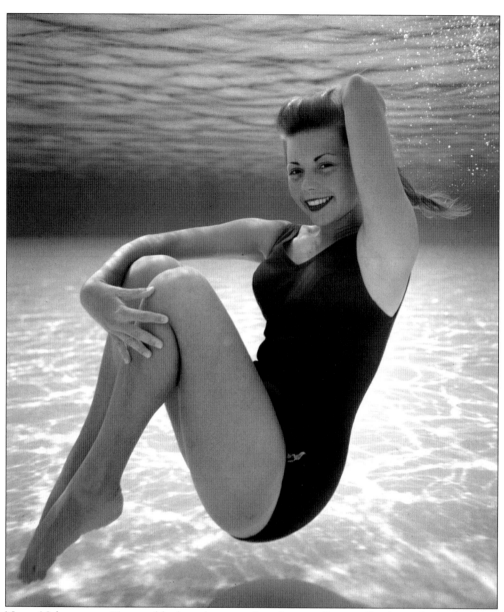

Neysa Nelms was a 15-year-old when she started working at Cypress Gardens; she worked as a swimmer and belle until her sophomore year of college. She is seen here in 1961 swimming in the Aquarama pool. High school students made $3 a day on Saturday and Sunday and $45 for a six-day week during the summer. She recalled: "Those of us that did the synchronized swimming also sat in the gardens wearing those cotton voile dresses that the Gardens' seamstress made in pastel colors; that along with a hoop skirt and 'bloomers.' During the winter we had black corduroy jackets, which were not 100% effective, so we bundled up underneath. Once during the winter, they had the belles waiting out on the take-off dock for the skiers. We were all huddled around a smudge pot for warmth. My dress caught fire! You'd think it would cause one to panic, but all I could think about, in slow motion, was that I felt very foolish and that I was going to have to jump in the water and it was going to be so cold. It was! They kidded me about docking my pay for the dress." (Courtesy Cypress Gardens.)

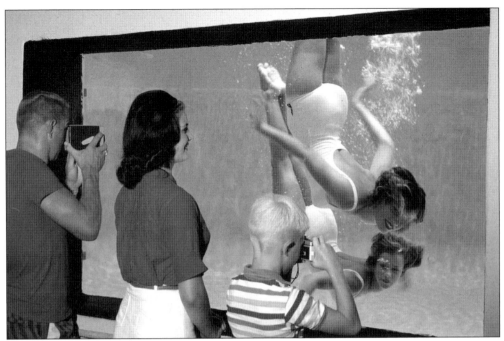

An underground chamber provided close-up views of synchronized swimmers in the Aquarama pool. Neysa Nelms Mazzarese recollected, "The pool was not heated. I remember they had a couple of us in a wet suit in the pool for a photo shoot once. We were in the pool all day long during the summer posing for tourists or practicing the synchronized swimming." (Courtesy Cypress Gardens.)

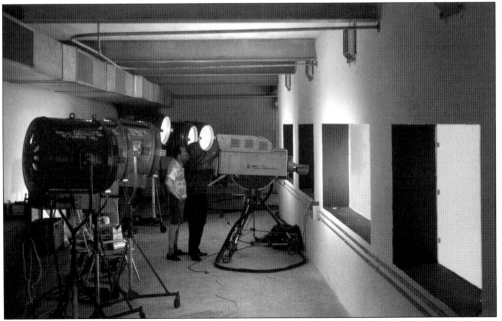

Scenes for the television special *Esther Williams at Cypress Gardens* were filmed through these windows of the Aquarama pool. The underground chamber was climate-controlled and provided as elaborate an underwater filming station as any in Hollywood. (Courtesy Cypress Gardens.)

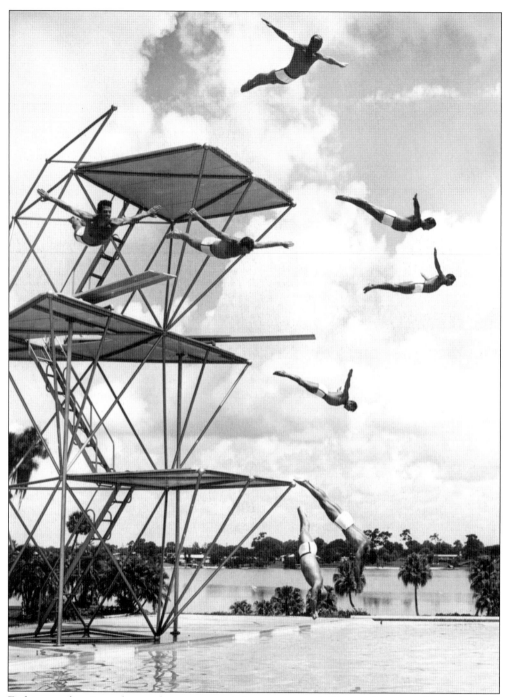

Eight men dive into the newly constructed Aquarama pool. Twenty-five years later, the pool became home to the Aquacade high dive show, with a cast of 30 champion performers. An expanded show followed the next year, with the highlight of "Aquacade '86" a 32-foot dive by a "human torch." Other elements of the water show included synchronized swimming and acrobatic ski-ramp jumping. (Courtesy Cypress Gardens.)

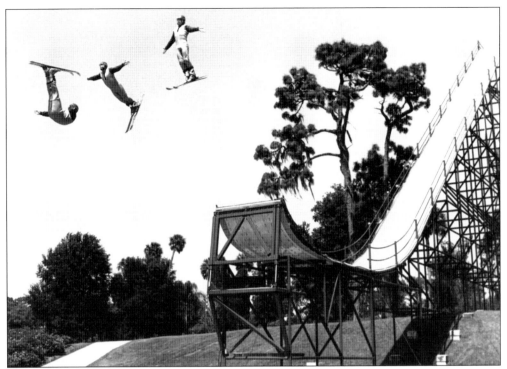

The "Snow Fliers" were snow-ski jumpers in a new environment: sunny Central Florida. As part of Aquacade '86, these daring performers skied down what was billed as the only poolside ramp in the country, an 88-foot-high permanent structure dubbed the "Showstopper." Twisting, turning, and flipping 45 feet in the air before landing in the water, these athletes were predecessors of today's X-Games competitors. (Courtesy Cypress Gardens.)

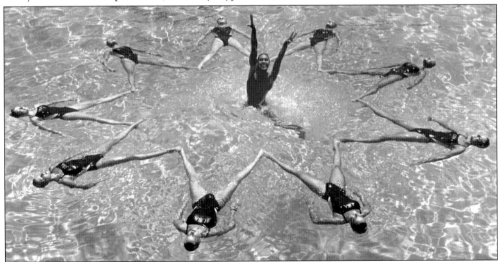

Tracie Ruiz-Conforto (center), double gold medalist at the 1984 Olympic Games, and members of the U.S. synchronized swimming team perform a starburst formation in the Aquarama pool reminiscent of early Cypress Gardens promotional photographs. In 1988, Ruiz-Conforto was serving as a special advisor to the gardens' Aquacade show swimmers, who performed several shows daily, and the Olympic champion occasionally joined the presentation. (Courtesy Cypress Gardens.)

The picturesque and functional Mut-Tel provided boarding for family pets in the 1950s and 1960s. Located adjacent to the main parking lot, the Mut-Tel was featured on period postcards. (Courtesy Cypress Gardens.)

This 1988 promotional photograph shows one of the unusual inhabitants of Cypress Gardens' accredited Animal Forest: a camel. The zoo—known earlier as the Living Forest and later as Nature's Way—featured more than 700 animals, including many rare and endangered species. (Courtesy Cypress Gardens.)

A pygmy hippopotamus born at Cypress Gardens in October 1986 was cause for much celebration. This was the second birth of a pygmy hippopotamus at the zoo, helping to preserve this endangered species native to western Africa. (Courtesy Cypress Gardens.)

The zoo was accredited by the American Association of Zoological Parks and Aquariums (AAZPA) in 1985, testament to the high standards maintained for animals and exhibits. A Critters Encounter program allowed guests to interact with animals, including rabbits, pygmy goats, baby camels, and Aldabra giant tortoises. An alligator handling demonstration, a 500-seat amphitheater-based exotic bird revue, natural animal habitats, and a 40-foot-high walk-through aviary were popular attractions. This December 1979 photograph shows one of the largest animal enclosures. (Courtesy Cypress Gardens.)

The year 1995 brought a display of 31 bronze, iron, sandstone, and steel sculptures to the park. This wildlife sculpture series included a polar bear, sea otter, humpback whale, and this 400-pound orangutan, named "Pongo." Ruth Ann Anderson of Lexington, Kentucky, watches her sons Cody and Brody explore the bronze figure. A portion of the proceeds from the sale of the sculptures went to the National Wildlife Foundation in an effort to support the endangered animals represented. The gardens presently include a number of wildlife sculptures, some so realistic that they are mistaken for living animals. (Courtesy Cypress Gardens.)

The Sunshine Sky Adventure ride extends 153 feet into the air with up to 100 riders, lifted by an almost 400-ton counterbalance, slowly rotating 360 degrees several times. From the top is afforded a magnificent view of the gardens, Lake Eloise, and the greater part of Polk County, extending as far as the county's highest point, the silhouette of Bok Tower in Lake Wales. The ride itself is a familiar landmark for miles. It was built in 1987 as Kodak's "Island in the Sky" and today is one of only three such rides in the world. (Courtesy Cypress Gardens.)

An aerial view from 1975 shows the central gardens from the west, including the Snively Mansion and the windmill, which was constructed as part of the Gardens of the World. Conspicuously missing are the many buildings that now comprise Jubilee Junction (formerly Southern Crossroads), the butterfly conservatory, the Sunshine Sky Adventure (formerly Island in the Sky), and the present-day park entrance. Most of these structures were completed during the 1980s. The Snively Mansion housed an impressive *Gone with the Wind* memorabilia exhibit before the park closed in 2003. (Courtesy Cypress Gardens.)

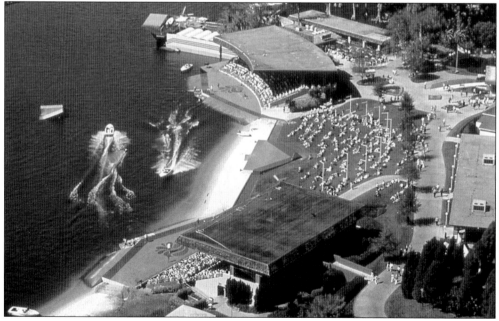

This image, dated 1987, shows the water-ski arena—including both stadia—during a show in front of a packed house. The northern stadium was completed in 1968, and work commenced on the second stadium in 1972. The dock for electric boats is visible at the top right of the photograph. (Courtesy Cypress Gardens.)

In 1986, visitors could pay a nominal fee for a relaxing ride in the Cypress Gardens Petticoach. Shown here in front of the Snively Mansion, the Petticoach drove through Southern Crossroads. (Courtesy Cypress Gardens.)

The new Wings of Wonder butterfly conservatory was the first climate-controlled botanical exhibit at Cypress Gardens in 1993, home to as many as 1,000 butterflies. Just outside, in front of the Snively Mansion, was the pristine Plantation Garden, home to aromatic herbs and roses. (Courtesy Cypress Gardens.)

In 1986, "Southern Ice" was the newest show at Cypress Gardens' Ice Palace. The themed ice revue was the only one of its type in the state and featured accomplished skaters in several daily shows. The ice surface was a 1,200-square-foot custom-made rink, and the arena was designed to permit elaborate special effects. Later ensembles included Russian skaters who performed a variety of shows during the year. When the park reopened, the arena had been rechristened the Royal Palm Theater, with elegant décor in the style of early-20th-century theaters. (Courtesy Cypress Gardens.)

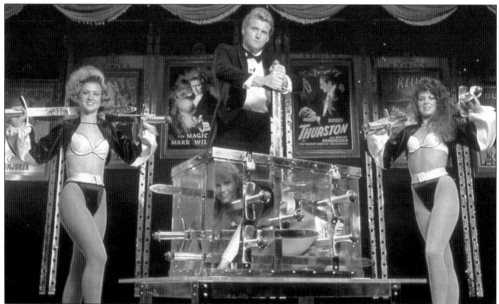

During the 1980s and 1990s, the park brought a variety of specialty acts to Winter Haven. These included magic, circus, and acrobatic troupes. These magic performers were at the park in 1990. (Courtesy Cypress Gardens.)

Captain Robin's Flying Circus performed at Cypress Gardens in 1990 in the covered outdoor Crossroads Arena, which eventually became the FloraDome. During the 1990s, several circus acts performed there under the billing of Varieté Internationale: the Akishins, the Dotsenkos, and the Sorokins. The European Circus Magic troupe performed from 1999 to 2001. (Courtesy Cypress Gardens.)

Southern Crossroads—completed in the early 1980s—was designed to resemble a small town, with specialty shops, dining, exhibits, and the Southern Ice arena. The brick-lined avenues were bordered by oaks, magnolias, and flowers. Bandstands featured live performances from Dixieland bands and other songsters, such as these carolers in 1988. The Little Colonels Corner was especially for youngsters, including pint-sized rides, arcade games, and real-live animated characters. (Courtesy Cypress Gardens.)

Architecture typical of Southern Crossroads is seen here in the Cypress Junction complex, home of the model train shop and Whistlestop USA. The scale of the buildings is in keeping with their surroundings. (Courtesy Cypress Gardens.)

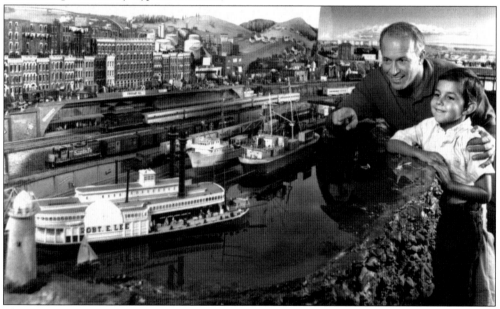

The HO-scale Model Railroad Exhibit was opened to the public in March 1984 as Whistlestop USA in Southern Crossroads and features 14 trains running over more than 900 feet of track past 350 buildings and 4,500 miniature figures. The layout re-creates vistas from across the United States, with minute detailing at every turn. Portions of the layout were created for the *National Enquirer* headquarters in Lantana, Florida, where it was part of an enormous Christmas display. A group of volunteers works two nights a week to maintain and further develop the layout. (Courtesy Cypress Gardens.)

Nine

CYPRESS GARDENS ADVENTURE PARK

The classic wooden Triple Hurricane roller coaster is named in honor of hurricanes Charley, Frances, and Jeanne, all of which passed through Polk County during the 2004 season. The hurricanes inflicted substantial damage locally and were a major setback to the construction phase as Cypress Gardens prepared to reopen. Unbowed, new owner Kent Buescher and his colleagues redoubled their efforts to resurrect the park, and the grand reopening took place in December 2004. (Courtesy Cypress Gardens.)

Kent Buescher—who enjoyed tremendous success as owner of Wild Adventures in Valdosta, Georgia—decided to purchase Cypress Gardens because he believed it would be a great park for families once again. Cypress Gardens had a strong 70-year history of serving families, but increasing competition from Orlando theme parks drew families and children away. He believed in taking the best of Cypress Gardens and adding the best of Wild Adventures to create a park that would be in demand by modern families. Buescher's vision gave great hope to those who loved Cypress Gardens, and his purchase and reopening of the park were wonderful news. The new Cypress Gardens Adventure Park will continue to add new thrilling rides, a larger variety of entertainment, seasonal events, and added water-park attractions as the demand grows. (Courtesy Cypress Gardens.)

The unusual Boardwalk Carousel double-decker merry-go-round and the Paradise Sky Wheel Ferris wheel are near the center of Adventure Grove. Over 40 rides await adventuresome park visitors. (Authors' collection.)

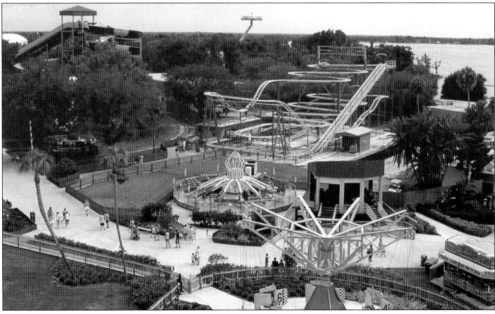

In a mix of old and new, the Sunshine Sky Adventure serves as a backdrop for the newest rides of Cypress Gardens Adventure Park. A sampling of other rides in Adventure Grove include the Swamp Thing, Okeechobee Rampage, Fiesta Express, Delta Kite Flyers, Mega Bounce, Storm Surge, Tilt-a-Whirl, Thunderbolt, Jalopy Junction, and the Sideswipers. (Authors' collection.)

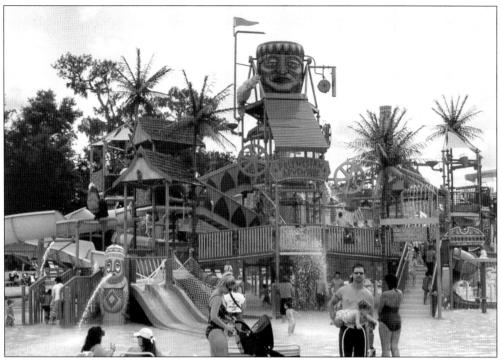

Thrill-seeking youngsters enjoy the 42-foot-tall Polynesian Adventure play area, loaded with interactive elements. Other features of Splash Island include Kowabunga Bay, a large wave pool; Tonga Tubes, a four-story twin water slide; and the 60-foot-tall Voodoo Plunge. The water park is located at the north end of the park; Tonga Tubes and Voodoo Plunge are on the former site of the Aquarama pool. (Authors' collection.)

Paradise River is part of the popular new water park. The waist-deep 1,000-foot meandering waterway passes beneath bridges and provides hours of relaxing inner-tube fun. (Authors' collection.)

Reopening of the park meant local skiing fans could see their favorites in action again. Among the skiers in 2006 were Kevin Baier, Erik Berglund, Valerie Berglund, Don Buffa, Linda Buffa, Catherine Ciccarello, Scott DePorter, Jessica Goldsmith, Hunter Hanson, Ben Jackson, Brian Jackson, Matt Jackson, Nick Jackson, Peter Kuhlmann, Jaclyn LeDoux, Howard MacCalla, Shawn Neuberger, Dan Olson, April Payeur, Brian Robbins, Jeff Schmick, Lindsey Schmidt, Shaune Stoskopf, Mark Voisard, Ryan Welch, Lindsay Wilmouth, and Angela Yauchler. (Authors' collection.)

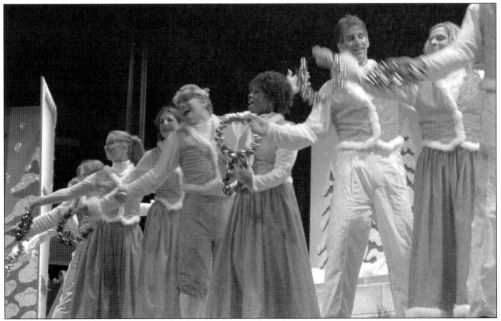

The 2005 Christmas season saw a return of grand holiday shows to the Royal Palm Theater. In addition to the "Christmas on Ice" show, crowds enjoyed "Holiday Homecoming," a musical wartime story of young love. (Courtesy Cypress Gardens.)

Chris Godbee, Swamp Critters bird handler, gives park visitors a personal view of his charge during a June 2006 presentation. The park features some 150 animals, including reptiles, mammals, and birds. Of particular interest is Tarzan, a 75-year-old alligator who starred with Johnny Weissmueller in classic *Tarzan* movies. (Authors' collection.)

Cypress Gardens Adventure Park returned with a flourish in 2004, and attendance figures for 2005 approached double the projected number. The core of the old park has been thoughtfully preserved, and the newest attractions have found a welcoming audience. (Courtesy Cypress Gardens.)

Sources Consulted

Branch, Stephen. "Florida with Flair: Dick Pope and the Making of Cypress Gardens." *Polk County Historical Quarterly* 30.2 (2003): 1, 4–5, 8–9, 12.

Cypress Gardens press kits, various years.

Desmond, Kevin. *The Golden Age of Water-Skiing.* St. Paul, MN: MBI Publishing Co., 2001.

Frisbie, Louise K. *Yesterday's Polk County.* Miami: E. A. Seemann Publishing, 1976.

Florida Cypress Gardens. Orlando: Florida Press, n.d.

Florida Cypress Gardens. Orlando: Vaughan, n.d.

Florida Cypress Gardens: Guide to America's Tropical Wonderland, Winter Haven, Florida. Chicago: Curteich, 1949.

Garrard, Dorinda, and Dorothy Manley. *Cypress Gardens History from Polk County Newspapers, 1935–2003.* Bartow, FL: Polk County Historical and Genealogical Library, 2003.

The Ledger (Lakeland, FL), various dates.

The Living Forest. Winter Haven, FL: Florida Cypress Gardens, n.d.

Mazzarese, Neysa Nelms. E-mail interview. 29 July 2006.

The New Cypress Gardens. Winter Haven, FL: Cypress Gardens, n.d.

Orlando Sentinel, various dates.

Polk County Democrat, various dates.

Pope, Dick Jr. Interview. 17 July 2006.

Pope, Dick Sr. *Water Skiing.* Englewood Cliffs, NJ: Prentice-Hall, 1958.

Recker, Kenneth, and Marcia Ford. *A History of the Winter Haven Lake Region Boat Course District.* Winter Haven, FL: The Canal Commission, 1986.

Williams, Esther. *The Million Dollar Mermaid.* New York: Pocket Books, 1999.

Winter Haven and Polk County City Directories, various years.

Winter Haven Herald, various dates.

Winter Haven News Chief, various dates.

ACROSS AMERICA, PEOPLE ARE DISCOVERING SOMETHING WONDERFUL. THEIR HERITAGE.

Arcadia Publishing is the leading local history publisher in the United States. With more than 3,000 titles in print and hundreds of new titles released every year, Arcadia has extensive specialized experience chronicling the history of communities and celebrating America's hidden stories, bringing to life the people, places, and events from the past. To discover the history of other communities across the nation, please visit:

www.arcadiapublishing.com

Customized search tools allow you to find regional history books about the town where you grew up, the cities where your friends and family live, the town where your parents met, or even that retirement spot you've been dreaming about.